BLACK AMERICA SERIES

IOWA'S
BLACK LEGACY

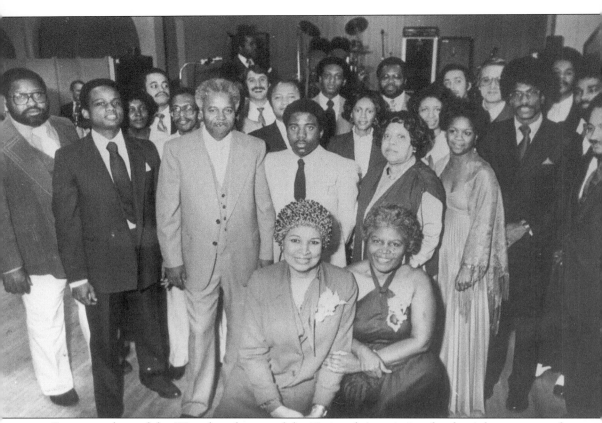

Some members of the Waterloo chapter of the National Association for the Advancement of Colored People (NAACP) are shown at the 1980 Freedom Fund banquet. (Courtesy of Floyd Bumpers.)

Black America Series

Iowa's Black Legacy

Charline J. Barnes and Floyd Bumpers

ARCADIA

Published by Arcadia Publishing,
an imprint of Tempus Publishing, Inc.
2 Cumberland Street
Charleston, SC 29401

Printed in Great Britain.

Library of Congress Catalog Card Number:

For all general information contact Arcadia Publishing at:
Telephone 843-853-2070
Fax 843-853-0044
E-Mail arcadia@charleston.net

For customer service and orders:
Toll-Free 1-888-313-BOOK

Visit us on the internet at http://www.arcadiaimages.com

Note: 1990 U.S. Census information was obtained by Iowa PROfiles: Public Resources Online at Iowa State University, Ames.

*To my family, for reliving history through storytelling on Saturday nights in Brooklyn;
to my teachers and mentors for encouraging me to live with the philosophy that
"all things are possible," and to those who came before and those who will come after,
for valuing the rich legacy of people of African descent. (CJB)*

*To my mother, Mrs. Lucille Creighton, who arrived in Iowa on the day I turned four
years old and has been here every since. Mother, you always saw the good in me,
and sometimes I did not see it myself. I love you mom! (FB)*

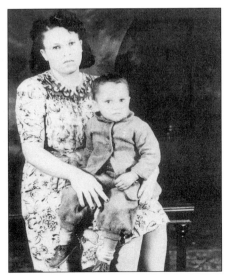

Lucille Fox Bumpers Creighton has lived in Waterloo for over 50 years. A native of Clark County, Alabama, she is pictured here in 1946 holding her eldest son, Floyd Bumpers.

CONTENTS

Foreword

Although African Americans have lived in Iowa since the middle of the nineteenth century, published studies of their history have been few in number and limited in scope. The authors are to be commended for this illustrated history that expands our knowledge of Iowa's Black heritage.

Their work is especially important from an educational point of view, because the schools in Iowa, like those nationwide, have not had the basic information for their curricula or even for their libraries. The schools of earlier generations were apparently uninterested in teaching the history of their minority citizens, but the civil rights movements of the late twentieth century created a desire to include the history of ethnic groups for the educational benefit of everyone. This is especially important for ethnic minorities who suffer from a lack of understanding of their heritage and the contributions their predecessors have made to the cultural and economic welfare of their state and nation.

Ideally, this book will encourage others, professionals as well as lay persons, to bring forth photographs and other information currently in private collections or unwritten memories. Those records should then be placed in libraries, county and state archives, and other community agencies where they are accessible to students, researchers, and other interested persons.

—Philip G. Hubbard
Professor Emeritus of Mechanical Engineering and
Vice President Emeritus, University of Iowa

Overview of African American Involvement in Iowa

In the early 1800s, African Americans came to Iowa hoping to find a better life. Unfortunately, a series of laws, known as "Black Codes," were passed that prevented many African Americans from settling in Iowa unless they could prove that they were not slaves. These laws also prevented African-American Iowans from voting, attending public schools, or testifying in court against European-American Iowans. In 1867, African-American Iowans joined together to lobby to have the Black Codes repealed. Some of these laws were repealed, but even with the passing of the Civil Rights Act in 1884 by the Iowa Legislature, most European-American Iowans ignored it for decades.

By 1900, thousands of African Americans came to Iowa to work in the coal mines located in southern and central Iowa. The great internal migration of African Americans moving from the rural South to urban areas throughout the United States also occurred. For many, this was the result of racial segregation, poverty, and loss of jobs due largely to the mechanization of cotton harvesting.

Both World Wars brought African Americans to Iowa for better employment opportunities. The 1930s found most of Iowa's African-American population employed in meatpacking plants, coal mines, and service industries. By the 1960s and 1970s, the Civil Rights Movement was underway throughout the United States. Many African Americans joined the demonstrations in Iowa for equal rights under the law.

Despite their small numbers in Iowa (2% of 2.8 million), African Americans have continued to push for recognition of their many contributions to the social, political, cultural, and economic evolution of the state.

—The Authors

INTRODUCTION

Before 1994, I lived on the East Coast. When moving to the Midwest, first to South Dakota and then to Iowa, many of my friends and acquaintances asked about the ethnic and racial backgrounds of the people in those two states. However, the majority of those questions were focused on the African-American population: "What is the size of the Black population? How did they get there since Iowa was not a slave state? What are the lifestyles of African-American people living in Iowa?"

Despite the fact that its largest minority population is only 2% of the state, Iowa has a rich African-American heritage, and I have discovered this in every trip that I have taken across the state.

This book, *Iowa's Black Legacy*, is the result of the inspiration of a longtime and special friend, Mrs. Cora Rust, who suggested that Floyd and I write about *some* of Iowa's Black heritage. Unlike a traditional history, this book is a photographic journey through Iowa's Black heritage. Most photographs are from the past, but there are a few contemporary ones. One major reason for this is—as an elder Black Iowan said—"we were too busy being the backbone of America to take and save pictures." Another reason is that most people had the photographs stored away and could not remember where or who had them within their families. A final reason was the timing of this project. Traveling throughout the state to research newspapers, church bulletins, and other historical documents was done while maintaining full-time responsibilities at a university and/or newspaper office. Floyd and I also spent time interviewing people and visiting former and current sites where Black Iowans made history. Some of these places were preserved; others were not. Regardless of any shortcomings, we hope this book will be the forerunner of much more documentation of Iowa's Black legacy.

This is our intention: to share some of these discoveries with our readers in this book. The resilience and tenacity of Black Iowans to survive against all odds is worthy of documentation. Most importantly, the impact on state and national history made by the many contributions of African Americans living in Iowa is impressive and worthy of promotion. This book makes both of these—documentation and promotion—possible for our readers.

—Charline J. Barnes, Ed.D.

I have lived in Iowa all my adult life. I migrated to Iowa shortly after I graduated from high school in search of employment and higher education. I have also done my share of traveling throughout the United States. Each and every time I take a trip and meet new people, someone says to me, "I did not know there were any Black people in Iowa!"

The discussion always led to other questions such as: "How many Black people live in Iowa? Have Black people always lived in Iowa or did they just migrate there after the Civil Rights bill was passed? Are there any famous Black people in Iowa? Why did Black people come to Iowa?" I, too, have asked many questions about the past and present lifestyles of African Americans living in Iowa.

The person that motivated and inspired Dr. Barnes and I to consider this book was Mrs. Cora Rust of New York, on my birthday. I am proud to say that two years later, again on my birthday, we completed the book.

It is our intention to inform our readers, from near and far, that Iowa does have a rich Black heritage. This book will inform the readers about ten cities in Iowa with large African-American populations. Hopefully, this book will answer some of the questions often asked by both residents and non-residents about the Black population in Iowa. The text and pictures will give a small view of Iowa's rich Black heritage.

—Floyd Bumpers

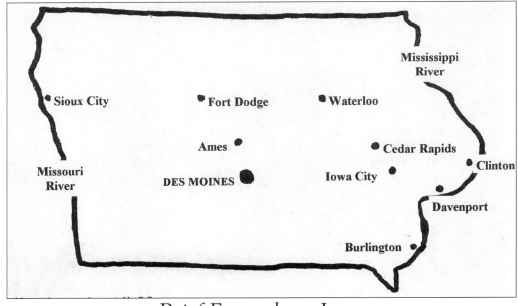

Brief Facts about Iowa

29th state to enter the Union (December 28, 1846)
Eastern boundary is the Mississippi River
Western boundary is the Missouri River
Called the "Hawkeye State"
Capital: Des Moines (originally a military outpost)
State Bird: Eastern Goldfinch
State Flower: Wild Rose
State Tree: Oak
State Rock: Geode
Birthplace of President Herbert Hoover

Birthplace of First Lady Mamie Doud Eisenhower
Birthplace of International Opera Star Singer Simon Estes
Birthplace of Actress Donna Reed
Birthplace of Actor John Wayne
First in pork, corn, and grain productions
Second in soybean production
Three state universities, 62 public and private colleges, and 28 community college campuses

One

AMES

<u>Early History</u>

Established in 1864 to serve the westbound Cedar Rapids and Missouri River Railroad, Ames is currently a university town. Originally founded in 1858 as the Iowa Agricultural College, Iowa State University (ISU) is the birthplace of the Atanasoff-Berry computer. Several of the first Black families established their homes in Ames, residing in separate communities around town. The Martin, Shipp, and Lawrie families became well-known African Americans in Ames. According to the local historian, Farwell T. Brown, Mr. and Mrs. Lawrie were tailors who established a shop on Kellogg and Main Streets around the 1920s. Their only child, John, would later relocate to Los Angeles. According to the 1990 U.S. Census, African Americans make up 2.5% of Ames population.

TOTAL POPULATION: 47,193 (1990 CENSUS)
AFRICAN-AMERICAN POPULATION: 1,190 (1990 CENSUS)

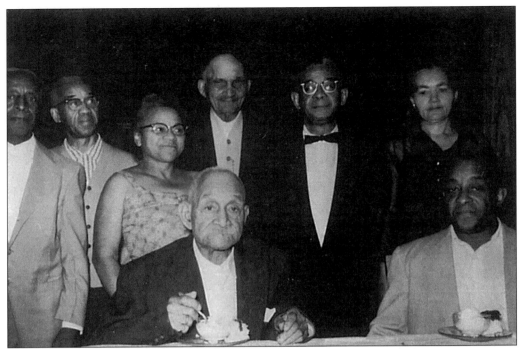

Archie (1858–1960) and Nancy (1857–1947) Martin moved from Georgia to Ames in 1915, where Archie worked for Chicago Northwestern Railroad. They had seven children. Pictured here is Archie, who is seated and eating cake and ice cream at his 101st birthday. Seated next to him is his son Paul. Standing, from left to right, are: son Ernest Simmons, son Archie Jr., daughter Nellie Martin Shipp, friend Thomas Jackman, son Robert, and daughter-in-law Esther Martin. (Courtesy of Pauline Martin.)

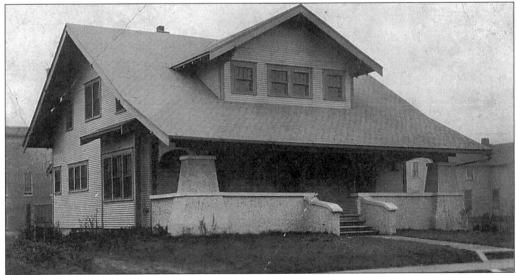

Archie and Nancy Martin built this house on 218 Lincoln Way. The house, still standing today, was used to board African-American students during the time when Blacks were not allowed to live in the ISU dorms. (Courtesy of Pauline Martin.)

One of Archie and Nancy's children, Paul Martin (1894–1973), married a local farmer's daughter named Esther. They built a house at 304 Washington Avenue for approximately $6,000 for a family of ten (one child died at age nine). Pictured is Paul, holding daughter Ruth. (Courtesy of Pauline Martin.)

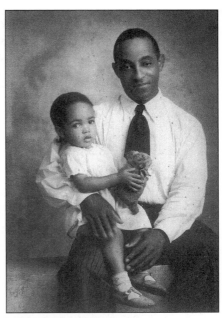

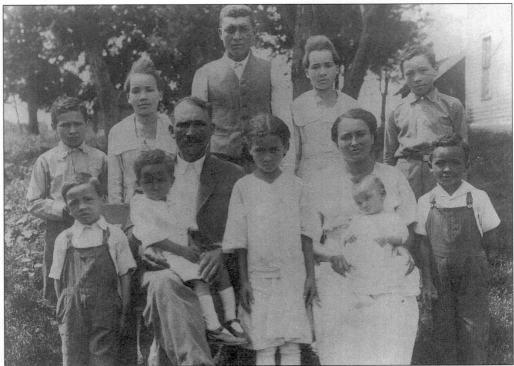

Esther Jackman Martin (1906–1961) came from a farming family of 13 children. Her mother, Willie Oneal, was a full-blooded Cherokee, and her father, Thomas, was of mixed heritage. Her twin, Ethel, who had polio at 11 years old, lived until 1981. Pictured is the Jackman family with ten of the older children. Esther stands (second from right) behind her mother, who is holding the baby. (Courtesy of Pauline Martin.)

Soon after the death of Esther Martin in 1961, her husband Paul insisted on a family photo. From left to right are: (seated) Jeremiah (Jerry), Pauline, Paul, and Marie Martin Mancuso; (standing) Barbara Martin Crawford, Norman, Mary Martin Carr, Paula Martin Freeman, and Ruth Martin Riffe. (Courtesy of Pauline Martin.)

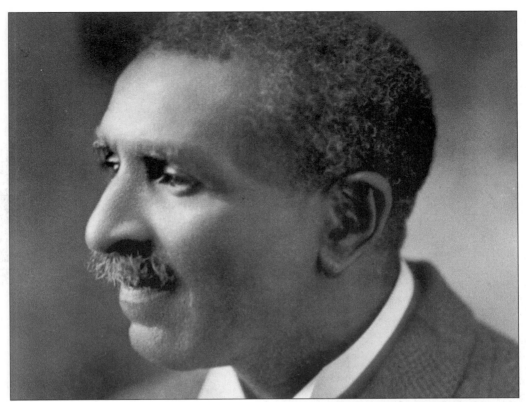

George Washington Carver was born a slave in the state of Missouri. The exact year of his birth is unknown. After being freed, he worked his way through Simpson College and Iowa State University, becoming the first Black student to graduate from Iowa State in 1896. At the encouragement of Booker T. Washington, Dr. Carver joined the Tuskegee Institute staff in 1896. He died in 1943 and is buried on the grounds of Tuskegee University (Courtesy of Iowa State Library/University Archives.)

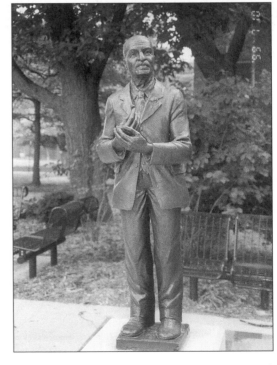

The renowned scientist, Dr. Carver, continues to be honored by Iowa State University. This photograph shows a statue of him outside a building on campus that bears his name. (Courtesy of *Waterloo United Communicator*. Photo by Charline Barnes.)

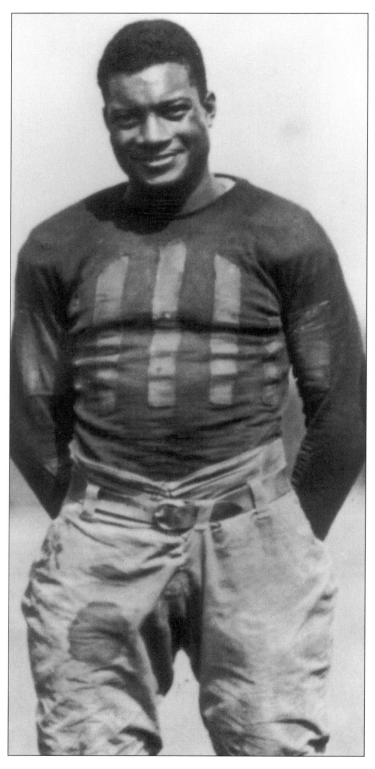

LEFT: FOOTBALL HERO JACK TRICE
In December 1983, Iowa State University officially named its football facility Jack Trice Stadium in honor of its first Black athlete. In October 1923, Trice died from fatal injuries that he received in a varsity football game against the University of Minnesota. He was born in 1902, the son of Green and Anna Trice, was borne in Hiram, Ohio. He became a star athlete at East Tech High School in Cleveland. When his football coach, Sam Williaman, was named head coach at Iowa State, Trice and six other athletes followed him to Ames. Trice majored in animal husbandry and, because there were no athletic scholarships granted in those days, he worked odd jobs to finance his education and support his wife (Cora Mae) and mother (Anna). A small bronze plaque recognizing Trice was rediscovered in 1973 in the old ISU gym. This began the battle to get the 43,000-seat facility named after Trice. (Courtesy of Iowa State Library/University Archives.)

Two

BURLINGTON

Early History

Located on scenic bluffs overlooking the Mississippi River, Burlington is a small southeastern city that dates back to 1805. The Sac and Fox Indians called it "Shoquoquon," meaning Flint Hills, due to the many flint-gathering sites in the area. A haven for runaway slaves, the city became the first Iowa Territorial Capitol in 1838. As a result, Burlington attracted water and rail traffic to develop industry and community growth. Its most famous landmark is Snake Alley, a street that consists of five half-curves, two quarter-curves, and a 58-foot drop over a 275-foot distance. Snake Alley has been featured on "Ripley's Believe It Or Not" television show. Burlington is also home to Iowa's oldest newspaper, *The Hawk Eye*. According to the 1990 U.S. Census, African Americans make up 4.4% of the Burlington population.

TOTAL POPULATION: 27,208 (1990 CENSUS)
AFRICAN-AMERICAN POPULATION: 1,212 (1990 CENSUS)

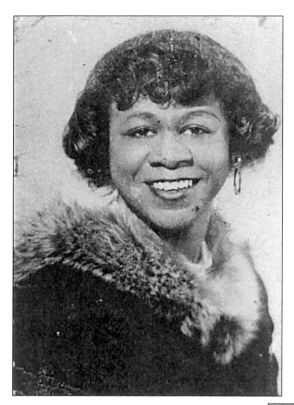

The National Association for the Advancement of Colored People (NAACP)-Burlington Branch was established in 1950 by 69 charter members. Helen Smith Ray (1921–1981) was one of these members. She is the sister of William A. Smith, the first Black person in Burlington High School's Clisthonian Debating Society. (Courtesy of Evangeline Ray.)

William A. Smith, an educator and minister, was the first African American to do many things in Burlington. A graduate of the local high school in 1929, he was the first Black on the honor roll, the first Black on the Clisthonian Debating Society, and the first Black to represent the high school at forensic contests. A football and track star at the local junior college (now Southeastern Community College), Smith went on to do doctoral work at Temple University. He died in 1973 in Florida, where he was last a pastor. (Courtesy of Evangeline Ray.)

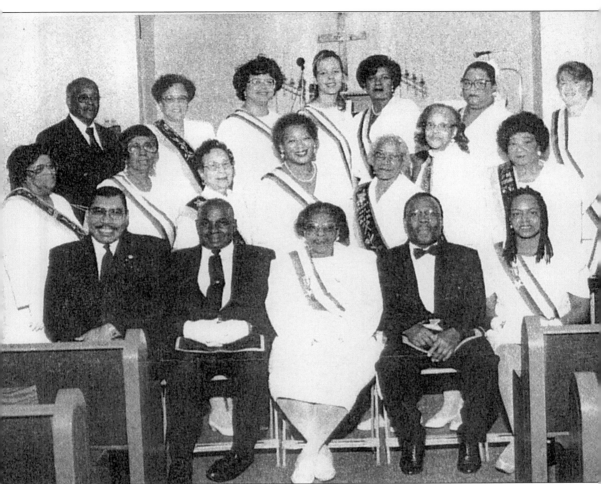

St. Elmo Chapter #3 Order of Eastern Star began in 1907. Pictured from left to right are: (front row) Owen T. Sloan, Past Grand Worthy Patron, Treasurer; Ernest Marsh, Past Patron; Maxine Snell, Associate Matron; Howard Payne, Worthy Patron; Laura Baker, Secretary; (second row) Evelyn Marsh, Past Worthy Matron; Johnnie Mathis, Sentinel; Charlotte Weldon, Past Grand Worthy Matron; Brenda Bates, Martha; Margaret Kinnard, Honorary Secretary; Helen Roach, Past Worthy Matron, Associate Conductress; Elmyra Benhart; (third row) Melvin Mathis; Carolyn Buckner, Grand Lecture; Barbara William; Willonda Lewis, Ada; Marva Margan, Associate Secretary; Mary Jo McCampbell, Electra; and April Morris. (Courtesy of Charlotte Weldon.)

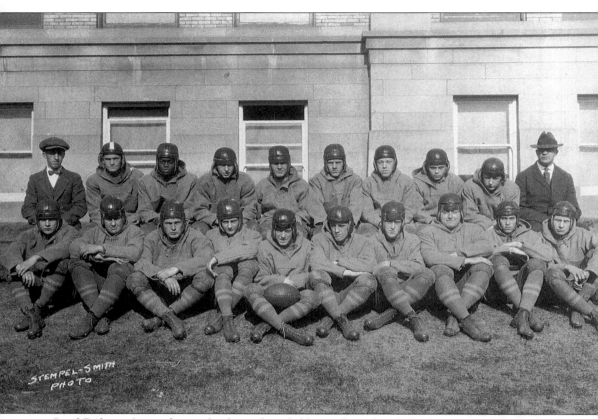

Cecil Rideout (second row, third seat from left) was the only Black player on the high school football team that won the state championship in 1924. A Second World War Navy veteran, Rideout became Burlington's first African-American bailiff, retiring in 1969. (Courtesy of Cecil Rideout.)

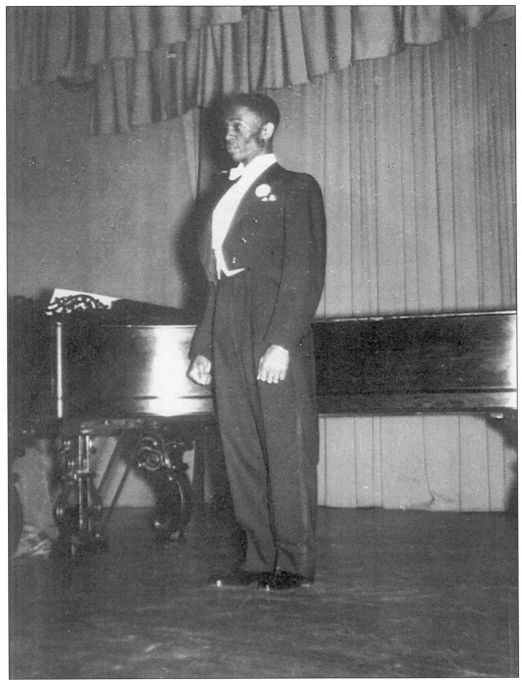

Cecil's love of music also made him famous in the Burlington area. He took voice lessons for 15 years and has sung solo and with quartets for over 70 years. His specialties are sacred, gospel, and classical music. He is shown here doing a concert in 1950. (Courtesy of Cecil Rideout.)

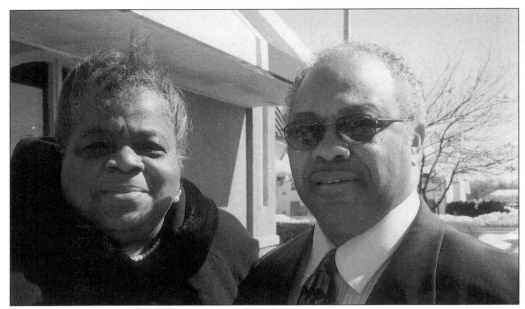

Since its early history, Burlington had integrated public schools. This was mainly the result of the small Black population and the anti-slavery activities in the area. Yet it would be the 1990s before Burlington elected its first African-American school board member. Pictured with wife Sara is Albert Sparks, a longtime resident who was elected to a three-year term on the school board in 1996. His slogan stated that a quality education should not be for one ethnic group. In 1995, the Sparks initiated a weekly tutoring program for elementary and middle school students. (Courtesy of *Waterloo United Communicator*. Photo by Charline Barnes.)

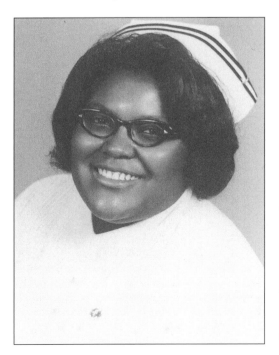

In 1950, an African-American female graduated from Mercy Hospital Nursing Training program to become the first Black nurse in Burlington. She worked at Burlington Medical Center for over 35 years. In 1972, Jaquelyn "Jaqui" Tolson (pictured) became the first Black student nurse at Burlington Memorial Hospital School of Nursing. She too would work for the medical center. Tolson also served as president of the local nurses union. (Courtesy of Jaqui Tolson.)

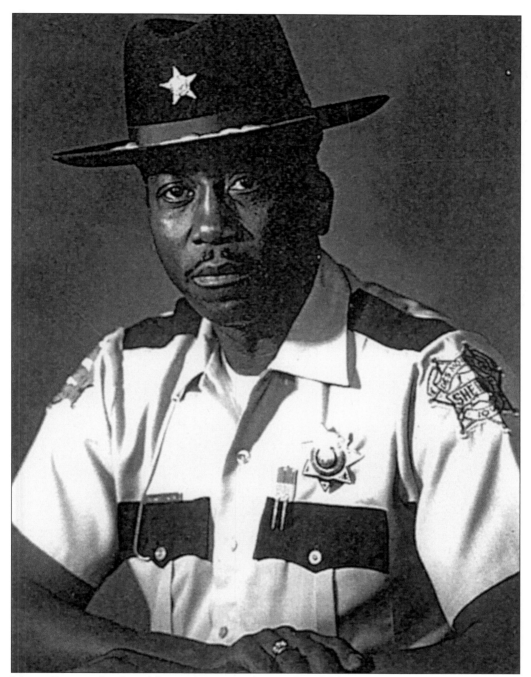

Morris Brown, the first African-American deputy sheriff of Des Moines County, served the community in many ways. He was actively involved in the local NAACP chapter, Faith Temple Church of God in Christ, Chamber of Commerce, Salvation Army, and the American Legion. A World War II Navy veteran, Brown also served for two years (1980–1982) as Burlington's Commissioner of Parks and Public Property. He died in 1998. (Courtesy of Marscine Brown.)

DeEdwin and Gladys White were community activists. DeEdwin, who died in 1995, was the first elected African-American city councilperson, serving Burlington from 1972 to 1976. Gladys, who died in 1985, served on many of the same organizations as her husband. In 1997, the former Maple Hills park in the four hundred block of Angular Street was renamed the DeEdwin and Gladys White Memorial Park in honor of this couple. Pictured is the couple, DeEdwin at 62 (seated left) and Gladys at 60, with an unidentified man in a pin-striped coat. (Courtesy of James R. White.)

The first Black U.S. Postal Service carrier in Burlington, DeEdwin also chaired the Iowa Civil Rights Commission and the Iowa NAACP. (Courtesy of Evangeline Ray.)

Three
CEDAR RAPIDS

Early History

The Cedar River runs through Cedar Rapids. The first white settlers, mainly of German, Czech, and Slovak heritage, immigrated to the area around the 1840s. They harnessed the power of the river, thus leading the country's grain markets with corn, oats, and other cereal products. In 1847, the first post office and school were built. In the late 1800s, some Black families moved to Cedar Rapids because of the railroad company based there. Later, employment with Quaker Oats (formerly called North Star Oatmeal Mill) and Collins Radio (now Rockwell Corporation) would offer better opportunities for many African Americans who migrated to Cedar Rapids in the early 1900s. Due to housing restrictions, most of the early Black families settled in the Oak Hill neighborhood.

In the early 1940s, a major shift in racial relations occurred at Cedar Rapids when Blacks were denied admission to the new Ellis Park swimming pool, a municipal facility. Before the pool, both Blacks and Whites swam together in the river. When some African Americans organized to protest this inequality in treatment, the result was the establishment of a local NAACP chapter in 1942, and full admittance for Blacks to the pool in 1945.

Today the people of Cedar Rapids are working on building the African American Museum and Cultural Center of Iowa. Its mission is to promote, publicize, and educate the public on the heritage of Black people. According to the 1990 U.S. Census, African Americans make up 2.9% of Cedar Rapids population.

TOTAL POPULATION: 108,751 (1990 CENSUS)
AFRICAN-AMERICAN POPULATION: 3,119 (1990 CENSUS)

The first entry in the abstract that pertains to our church was as follows:

#107 "John F. Ely and : Warranty Deed
 Mary A. Ely, his : Dated June 8, 1874
 wife" : Filed December 22, 1974
 to : Recorded Vol. 18 pg. 75
 " The African Methodist : Description, "The follow-
 Episcopal Church of Cedar : ing described premises in
 Rapids, Linn County, Iowa', : the County of Linn, State
 of the County of Linn and : of Iowa, to-wit: 40 feet
 State of Iowa" : by 60 feet of ground from
 : and off the South East end
 : of Lot 1 in Block 45 in the

Town of Cedar Rapids as designated on the recorded plat of said Town, being 40 feet front on Monroe Street and extending same width through said lot."

In 1871, the African Methodist Episcopal (AME) Church of Cedar Rapids was organized. As noted in the abstract, John and Mary Ely, a prominent White Cedar Rapids family, donated the land on which the church stands at 512 Sixth Avenue Southeast. The church was later incorporated in 1931 as Bethel AME. (Courtesy of Larry Floyd/Bethel AME Church.)

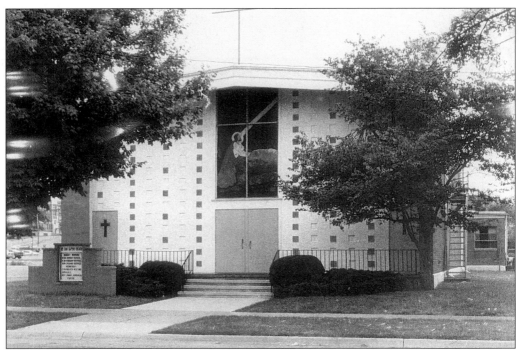

Mt. Zion Missionary Baptist Church came into existence in 1914. The first church building was purchased from Huss Memorial Church and moved to the present site at 824 Eighth Street Southeast. On March 22, 1958, this wooden building was destroyed by fire. By November 1958, a new brick church stood on the same site. In 1962, Rev. Sterling Miller painted the mural that can be seen in the front window of the church. An educational wing was added in 1979. (Courtesy of Lonnie J. Jordan III/Mt. Zion Missionary Baptist Church.)

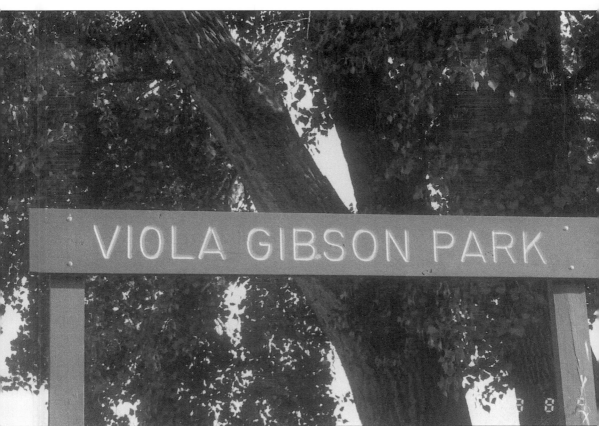

Viola Gibson, a longtime religious and human rights leader in Cedar Rapids, was one of the founders of the local NAACP. Her family came to the Midwest from Tennessee when she was a young girl. She died in 1989. Today a park in Cedar Rapids (pictured) is named after this community activist. (Courtesy of *Waterloo United Communicator*. Photo by Charline Barnes.)

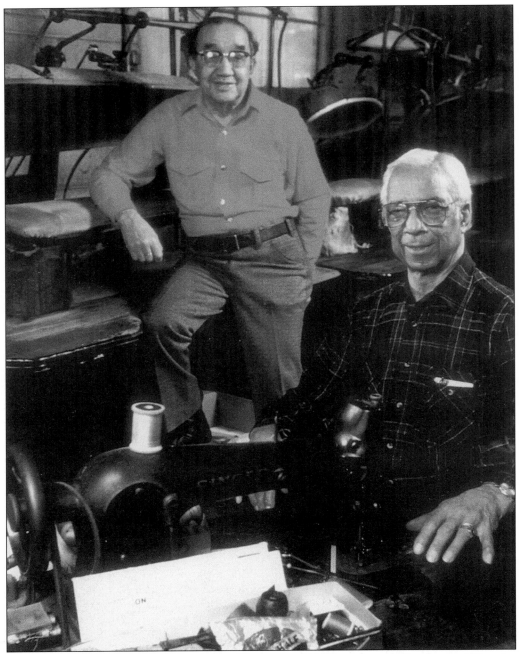

In 1935, Tom Mason opened Mason's Dry Cleaning at 119 Third Avenue Southwest. When he relocated to Chicago, Elmer T. Smith (d. 1992) would purchase the business in 1946. His brother, Louis, joined him in the business in 1948. They moved the dry-cleaning business to 214 Fifth Avenue Southwest in 1953. (Courtesy of Vivian Smith.)

In 1970, Elmer T. Smith became commander of the Hanford Post No. 5, The American Legion. He was the first and only African American in Cedar Rapids to be elected to this position. Here is a copy of his first Commander's Message in the monthly newsletter. (Courtesy of Vivian Smith.)

Commander's Message . . .

ELMER T. SMITH
COMMANDER HANFORD POST NO. 5
THE AMERICAN LEGION
Cedar Rapids, Iowa

TO THE COMMANDER, OFFICERS, AND MEMBERS OF HANFORD POST

I wish to humbly thank you for electing me to serve as your Commander. I accept this position, knowing full well the responsibilities of the office. I deem it an honor and a privilege and will endeavor to fill this post to the best of my ability.

I am optimistic about the future of Hanford Post, but I do not expect this year to be easy. It will not be easy partly due to the economic conditions and because of the social unrest that prevails in the country today. So, I take this opportunity to ask the Officers and Membership for help. Your assistance is needed in the several programs to keep Hanford a bigger and better Post.

My congratulations to Mrs. Barrett. To my knowledge this is the first joint installation with the Auxiliary, a practice that should become a custom and only be the beginning to a better understanding and co-operation for the good of The American Legion.

Again, I thank you.

ELMER T. SMITH

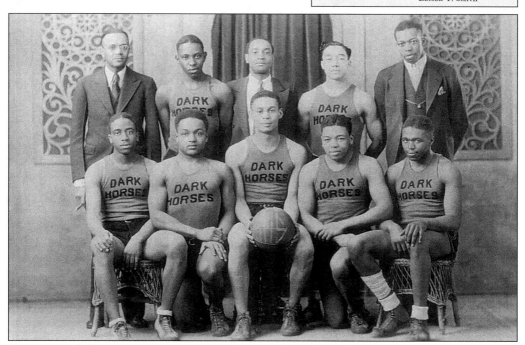

Due to racial discrimination in organized sports throughout the United States, the African-American community established its own teams. Pictured is the Cedar Rapids Dark Horses Basketball team in the late 1920s. Dr. Beshears, the first Black dentist in Cedar Rapids, is in the back row (first person on the left). Elmer T. Smith is standing second from right. (Courtesy of Vivian Smith.)

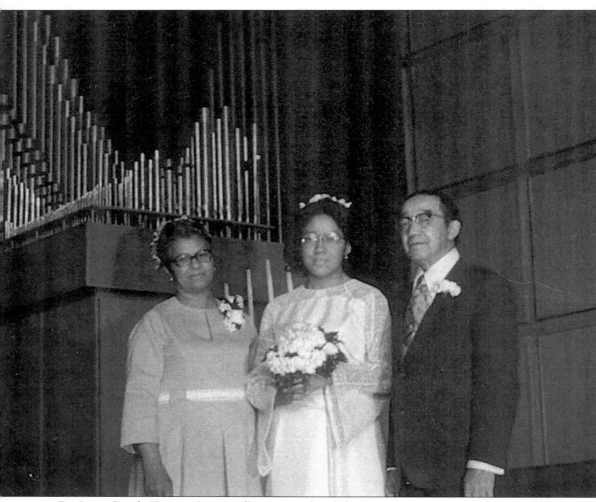

Dr. Janet Smith-Kintner (centered) is pictured with her parents, Vivian and Elmer Smith, on her wedding day in 1971. Dr. Kintner, a graduate of Washington High School, became the first African American from Cedar Rapids to receive a BA in physics from Grinnell College. She would obtain her doctorate from the University of Minnesota and join the faculty at Cornell University in 1976. Dr. Kintner is now deceased. (Courtesy of Vivian Smith.)

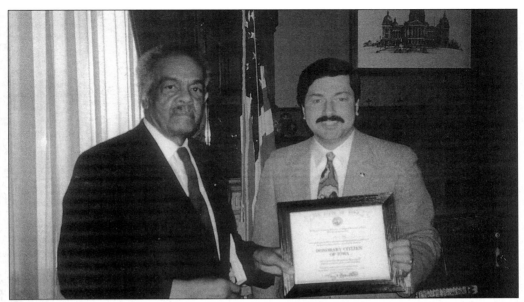

Cecil Reed (b. 1913) became the first African-American Republican in the Iowa House of Representatives in 1967. He tells his life story in *Fly in the Buttermilk*. Here former governor of Iowa, Terry Branstad, is honoring him. (Courtesy of Cecil Reed.)

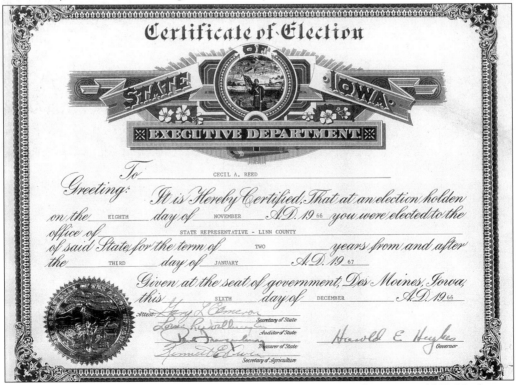

Former state representative Reed served under former governor of Iowa Harold E. Hughes, as indicated on his certificate of election. (Courtesy of Cecil Reed.)

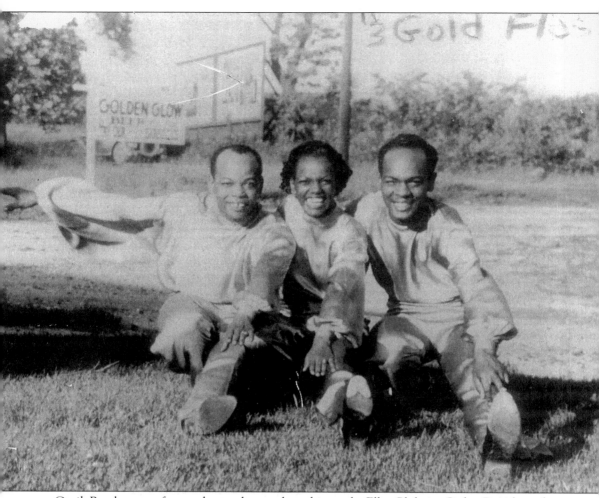

Cecil Reed was a former bartender at the white-only Elks Club in Cedar Rapids and an entertainer before becoming a business owner and legislator. Pictured from left to right are siblings Wally, Edith, and Cecil in 1937, posing as the Three Gold Flashes in front of the Old Hickory located on First Avenue and Fortieth Street. Although Edith Reed Atkinson went to work full-time at Collins Radio (now Rockwell), she became well known in the Linn County area for her ability to sing in six languages and for her work with young people in the music area. (Courtesy of Cecil Reed/Edith Reed Atkinson.)

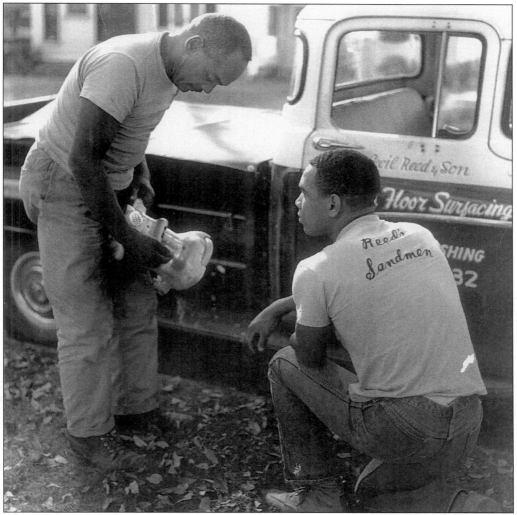

Cecil Reed became owner of several businesses in Cedar Rapids. Pictured here (left to right) is Cecil, with his son, Richard, preparing for a flood-sanding job. They were the first Black members of the Cedar Rapids Carpenter and Joiner's Union, Local 308. (Courtesy of Cecil Reed. Photo by Joan Liffring.)

Since 1997, Henry Davison has owned and operated H.D. Youth Center at 1006 Third Street Southeast. The center is a safe, drug-free, and positive environment where young people can study and play together. Davison, a retired Collins Radio (now Rockwell) employee, is pictured in his military uniform while stationed in Korea. (Courtesy of Henry Davison.)

Four

CLINTON

<u>Early History</u>

About 138 miles west of Chicago, Clinton is located on the eastern boundary of Iowa. The mighty Mississippi River runs along this boundary. Known as the "Lumber Capitol of the World" in the late 1800s, Blacks settled there mainly because of the railroad industry. Today, Clinton is now an agricultural and light-industry area with an historic riverfront. According to the 1990 U.S. Census, African Americans make up 2.4% of the Clinton population.

TOTAL POPULATION: 29,201 (1990 CENSUS)
AFRICAN-AMERICAN POPULATION: 699 (1990 CENSUS)

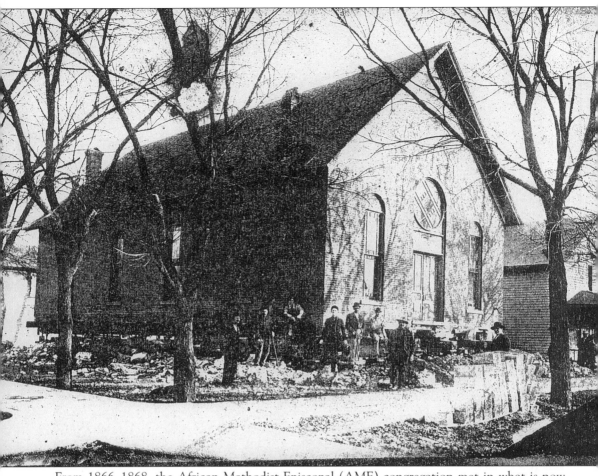

From 1866–1868, the African Methodist Episcopal (AME) congregation met in what is now the parsonage of Bethel AME Church (formerly known as Second Methodist Episcopal Church, Colored). Through the efforts of J.H. Young and members of First United Methodist Church, the lot on the corner of Third Avenue South and Third Street was deeded to the church by the Iowa Land Company. In 1868, the first building on this property cost $600, and in 1884, the second facility was constructed at a cost of $2,000. The current members are using this last building (pictured). In 1935, former member William C. Jetter and other hunters would begin the traditional wild game dinner at Bethel AME Church. The annual dinner on the Thursday before the traditional Thanksgiving holiday is held to give everyone a taste of wild game. Stories of the early event are told during this long-lived tradition. (Courtesy of Vinson Jetter.)

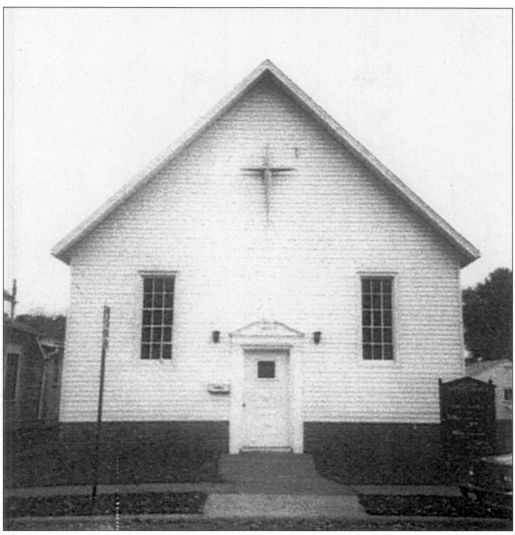

In 1887, the oldest African-American Baptist church in Clinton was organized as Second Baptist Church at 438 Fourth Avenue North. The officers were Jerry Taylor, Harvosol Parm, Adam Taylor, and William Brown. The first recorded pastor was Rev. Washington. The property was originally in the name of First Baptist Church, but in 1912 it was deeded to Second Baptist Church. In 1994, the church purchased additional property at 522 Fourth Avenue North. (Courtesy of Debbie Green/Second Baptist Church.)

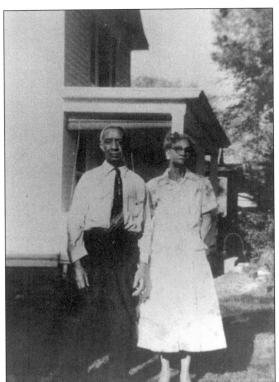

James D. "Bounce" (1889–1959) and Lula K. "Katie" (1889–1977) Wallace came from Missouri to Iowa around 1910 to work on a project for the railroad. The Wallaces and their oldest daughter, Iola, lived in a boxcar during this time. At the completion of the project, they stayed in Clinton; James D. "Bounce" did odd jobs and Lula "Katie" cleaned homes. They had three more children— Ruth, James A., and Winifred. Lula "Katie" helped to start the local National Association for Advancement of Colored People (NAACP), served as a Red Cross (Grey Lady) volunteer, and was a member of Second Baptist Church. Pictured are James D. and Lula, outside their Clinton home on Second Avenue North (formerly Maple Avenue). (Courtesy of Debbie Green.)

Pictured are the Wallace children with their mother. From left to right are: Ruth, mother Lula "Katie," Winifred "Winnie," Iola, and James A. James became the first Black drum major at Clinton High. (Courtesy of Debbie Green.)

In January 1936, Clemmie Odella Lane Hightower arrived in Clinton to join her husband Lowell, who was working as a janitor at the Lafayette Hotel. Lowell would later be employed at DuPont for 37 years. He died in 1979. Lowell met Clemmie in Oklahoma, where she lived with her grandmother and aunt. An influenza epidemic claimed the life of Clemmie's mother, Louisa. Here is Clemmie at age six. (Courtesy of Clemmie Hightower.)

Pictured are five generations of Clemmie Hightower's family. From left to right are great grandmother and ex-slave Amanda Huggins (seated in the center), Clemmie at age 20 holding baby Una, Clemmie's daughter Lowetta at 2¹/₂ years, Aunt Idella Williams Green, and Grandmother Maggie Williams. (Courtesy of Clemmie Hightower.)

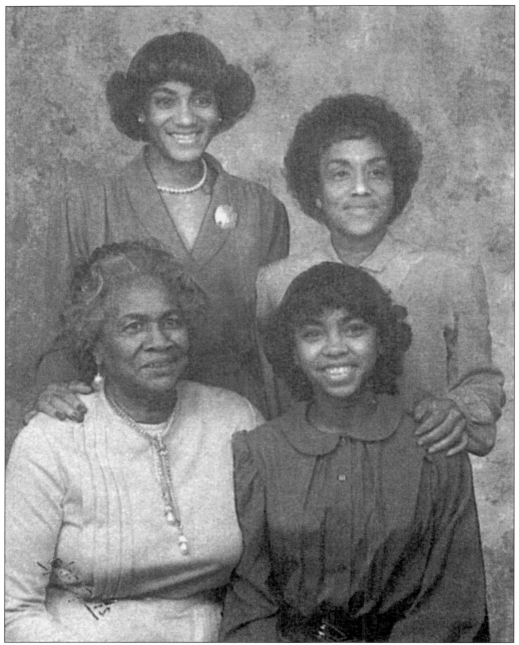

Pictured is the Hightower family in 1984. Seated from left to right are Clemmie and granddaughter Robin (Una's daughter). Standing from left to right are daughters Una and Beverly. The oldest daughter, Lowetta Hightower Yates, died in 1997. All three Hightower daughters graduated from the University of Iowa. (Courtesy of Clemmie Hightower.)

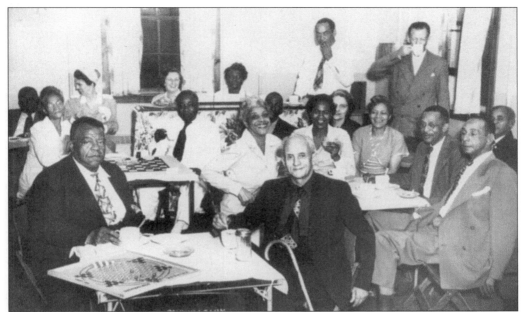

Hightower has been a volunteer in the Clinton area for more than 60 years. Besides the Red Cross and YWCA, she was appointed by former governor Terry Branstad as a Commissioner for the Iowa Department of Elder Affairs. Pictured are Katie Wallace, Bessie Stuart, Mary Freels, Clemmie Hightower, and Grace Peak, some of the Grey Ladies of Clinton Chapter of the Red Cross, at a 1945 party for wounded servicemen. Although the Red Cross did not accept Black people's blood during this time, it allowed them to serve as volunteers in other capacities. (Courtesy of Clemmie Hightower.)

Mary Catherine Freels (1892–1994) was a longtime member of the Republican Women's Club and a 50-year-plus member of Electra Grand Chapter, Order of the Eastern Star and Second Baptist Church. Here is Mary wearing a crown at her 100th birthday celebration in Clinton with her nieces. From left to right are: Vicki Fulton with her three children standing in front, Sandra Soto, Winifred "Winnie" Wallace Green, Cathy Wallace Phillips, Paula Taylor, Goldye Ward, Mary, grandson Terry Freels, and Corrinne Perkins. (Courtesy of Phil Hubbard.)

William C. Jetter (1906–1988) founded Jetter Hauling Service around the late 1940s. He married Margaret Culberson in 1943 and they moved to Clinton and became active members of Bethel AME Church. In 1968, William (Bill) Jr. joined in partnership with his father, and in 1984, William Sr. sold the business to him. (Courtesy of Vinson Jetter.)

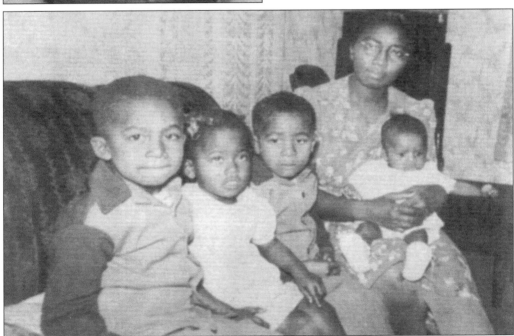

Several of the Jetter children, pictured from left to right, are: William (Bill) Jr., Dorothy (Dina), Vinson (Vince), and Marguerite holding John (Jack). In 1988, former governor Terry Branstad presented an award to Bill for the Outstanding Minority Business from the Iowa Department of Economic Development. Jetter sold the Clinton's business in 1998 and reopened in the Quad Cities area. Another business, Jet Ribs, was the partnership of William Sr. and Vince. (Courtesy of Vinson Jetter.)

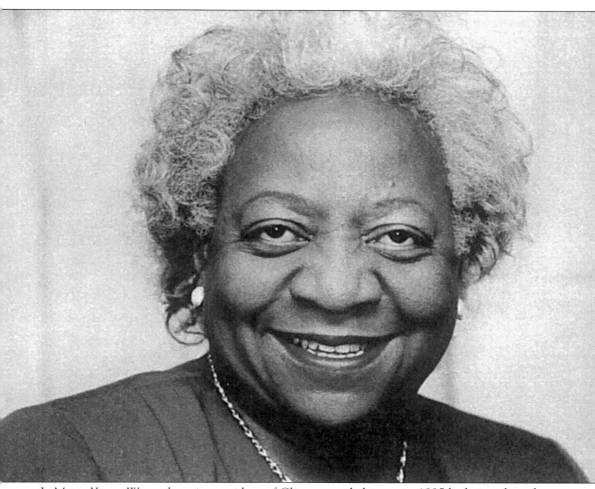

LaMetta Karen Wynn, longtime resident of Clinton, made history in 1995 by being elected as the first Black female mayor in Iowa. She took office in January 1996. Since 1955, she worked as a registered nurse in a variety of capacities within the Samaritan Health System in Clinton. She received her nursing degree from St. Luke's Hospital School of Nursing in Cedar Rapids. She served on Clinton Community School Board from 1983–1995, and was president of the school board for three years. Wynn is a widow and mother of ten children—nine daughters and one son. (Courtesy of LaMetta Wynn.)

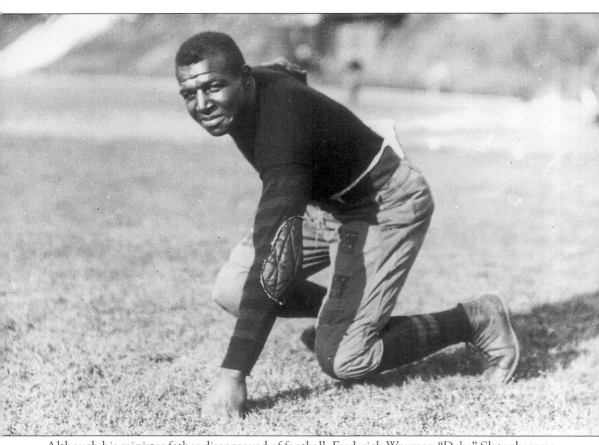

Although his minister father disapproved of football, Frederick Wayman "Duke" Slater became an all-state tackle during his years at Clinton High School. He played college (University of Iowa) and professional (old American Football League) football. Slater was named to the National Hall of Fame in 1956. After graduating from the University of Iowa in 1922, this athlete would return to his alma mater to earn a law degree in 1928. Slater was admitted to the Illinois bar in 1929, and became a judge of the Illinois Circuit Court from 1960–1966. He died on August 15, 1966, in Chicago. In 1972, a men's dormitory was renamed Slater Hall on the University of Iowa campus. It was the first building on the campus to be named for an African American. (Courtesy of University of Iowa Archives.)

Five

DAVENPORT

Early History

Davenport, located on the Mississippi River, is about 160 miles from Chicago. It is part of the area known as Quad Cities—Bettendorf, Iowa, and Rock Island and Moline, Illinois. Davenport was established in 1836 as a river town and, later, as a railroad center. It is home to the Palmer College of Chiropractic, which opened in the 1920s. It is also home to the Bix 7-Mile Run, a road race that remembers Bix Beiderbecke, a jazz cornet star from the 1920s. According to the 1990 U.S. Census, African Americans make up 7.8% of the Davenport population.

TOTAL POPULATION: 95,333 (1990 CENSUS)
AFRICAN-AMERICAN POPULATION: 7,455 (1990 CENSUS)

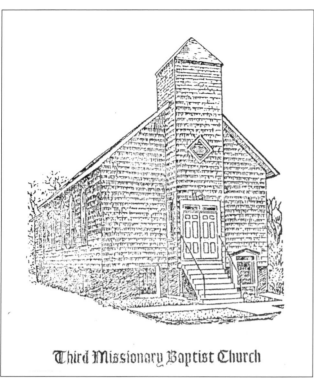

Third Missionary Baptist Church

Third Missionary Baptist Church is the oldest Black Baptist church in Davenport. It began in 1875. The members stayed in this building until 1969. (Courtesy of Ethelene Boyd/Third Missionary Baptist Church.)

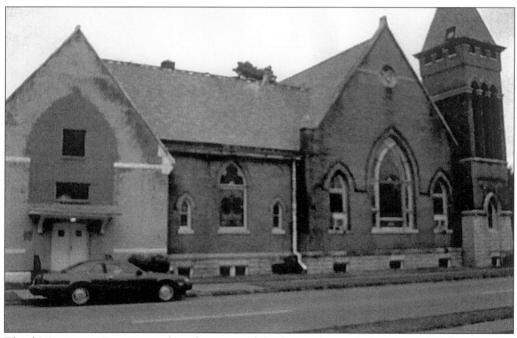

Third Missionary Baptist purchased its second facility and stayed there until 1999, when the members constructed a new church about one block away. (Courtesy of Ethelene Boyd/Third Missionary Baptist Church.)

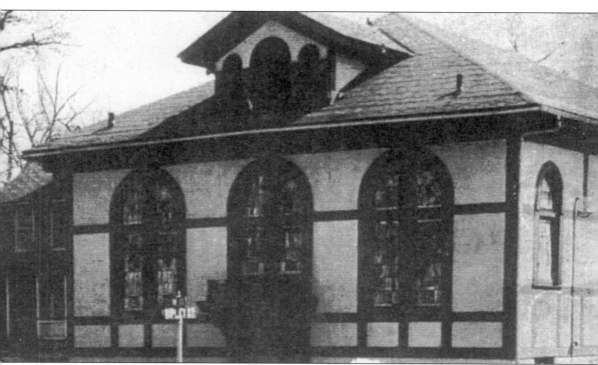

Bethel African Methodist Episcopal (AME) Church was founded in 1866. It was originally called AME Church, Davenport. Pictured here is the church building that was completed in 1912. The congregation is still using this facility. (Courtesy of Vernell Compton/Bethel AME Church.)

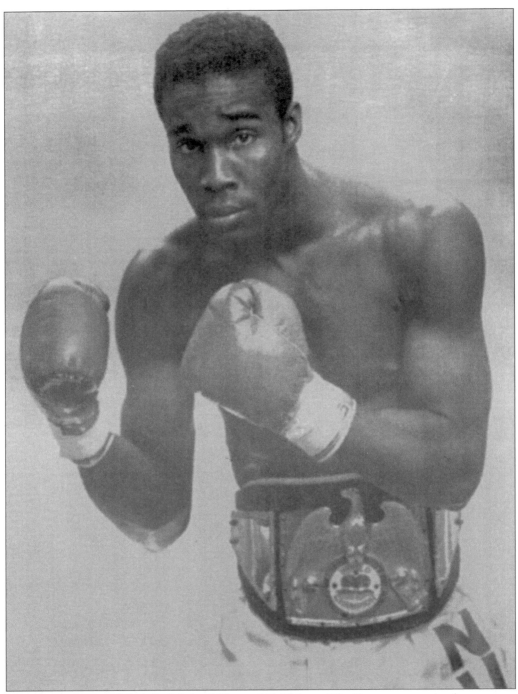

This is a promotional flyer for Michael "Second To" Nunn. The Davenport-native boxer was a former IBF middleweight and WBA super middleweight champion. (Courtesy of Mrs. Nunn.)

Pictured here is high school senior Ethelene Boyd. Boyd, a Davenport teacher since 1972, grew up in Chicago. In 1983, she became the first Black president of the Davenport Education Association. (Courtesy of Ethelene Boyd.)

Pictured are the three principals of Lincoln Elementary, a magnet school in Davenport. Left to right are: Tom Smith, the first Black administrator in the school system; Verlyn Siglin; and Henry Caudle. (Courtesy of Ethelene Boyd.)

When Dr. Lafayette J. "L.J." Twyner returned to his hometown to practice dentistry, he could not find an office to rent because he was Black. It was Arthur Griggs Sr. who finally rented him space on Harrison Street. Dr. Twyner, a dentist in Davenport for more than 40 years, would later move his practice to Locust Street. He graduated in 1943 from St. Ambrose College (now St. Ambrose University) and University of Iowa College of Dentistry in 1947. He served as a first lieutenant in the army during the Korean War. Dr. Twyner was first elected to the Davenport School Board in 1969 (the first African American in Davenport), and upon his death in 1992, he was serving his eighth term on the board. (Courtesy of Kathleen Twyner.)

Dr. Twyner and his wife Rosemary (she died in 1988) produced three daughters, Alexis, Brenda and Kathleen, and one son, Lafayette Jr. "Buck," who all achieved advanced professional degrees. The children have established a scholarship in their father's name for an underprivileged student from Central High School (formerly Davenport High School, from which Dr. L.J. Twyner graduated). Pictured is Twyner with his three-month-old granddaughter Rosemary. (Courtesy of Kathleen Twyner.)

Six
DES MOINES

Early History

Des Moines, the capitol of Iowa, is rich with history. For early African Americans arriving in Iowa, Des Moines became a place of education and economic and cultural opportunities. In fact, many of the major events that affected Iowa's Black population resulted from the involvement of Des Moines Black residents. For example, the first chapter of the National Association for the Advancement of Colored People (NAACP) in Iowa began in Des Moines in 1915. The National Bar Association, the nation's oldest and largest professional association of predominately African-American lawyers and judges was formally organized in Des Moines in 1925. The charter members were George H. Woodson, S. Joe Brown, Gertrude E. Rush, James B. Morris, Charles P. Howard Sr., Wendell E. Green, C. Francis Stradford, Jesse N. Baker, William H. Haynes, George C. Adams, Charles H. Calloway, and L. Amasa Knox. During World War I, Des Moines became the site for the U.S. Army's Colored Officers Training Camp, the first of its kind. Overall, Des Moines has produced many Black leaders who have made significant contributions to the nation and the world. According to the 1990 U.S. Census, African Americans make up 7.0% of the Des Moines population.

TOTAL POPULATION: 193,187 (1990 CENSUS)
AFRICAN-AMERICAN POPULATION: 13,667 (1990 CENSUS)

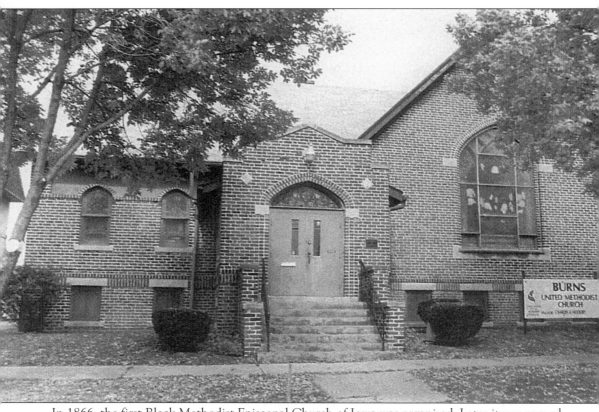

In 1866, the first Black Methodist Episcopal Church of Iowa was organized. Later it was named Burns United Methodist Church in honor of Francis Burns, the first Black Bishop of Episcopal Methodism. The congregation first met in a building at East Second and Maple Street. In 1903, it built a church at Twelfth and Crocker Streets, but lost it through some misfortune (the cause is unknown). Pictured is the current church building at 811 Crocker that Burns's members purchased in 1928 from the Crocker Hill Methodist Church (now known as Immanuel United Methodist). A 1947 fire badly damaged this facility, but the church was restored. In 1977, Burns made the National Register of Historic Places as Iowa's oldest Black congregation. (Courtesy of Leola Davis/Burns United Methodist Church.)

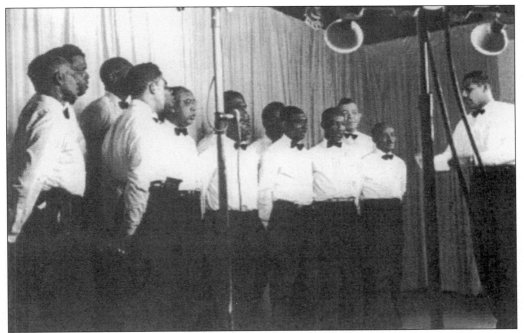

Pictured is Burns's male chorus singing at the Iowa State Fair in 1946. (Courtesy of Leola Davis/Burns United Methodist Church.)

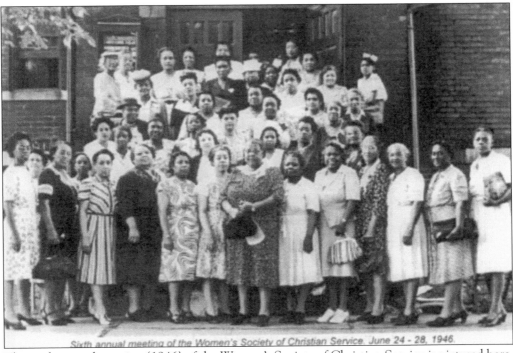

Sixth annual meeting of the Women's Society of Christian Service. June 24 - 28, 1946.

The sixth annual meeting (1946) of the Women's Society of Christian Service is pictured here. (Courtesy of Leola Davis/Burns United Methodist Church.)

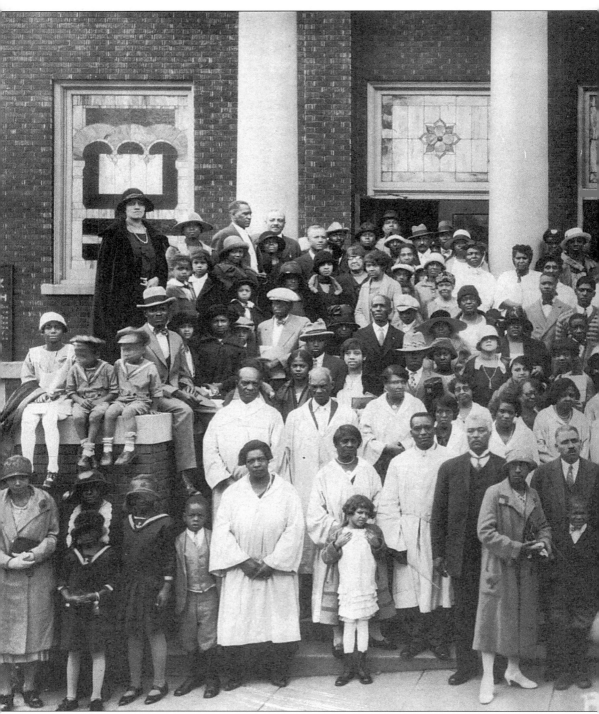

St. Paul African Methodist Episcopal (AME) Church was established in 1872. The charter members were: Anna Allen, Archie Brown, Amanda Carter, Bell Carter, Isiah Carter, Jennie Carter, Louise Carter, Margaret Carter, Rachel Carter, Sampson Carter, Nan Cothran,

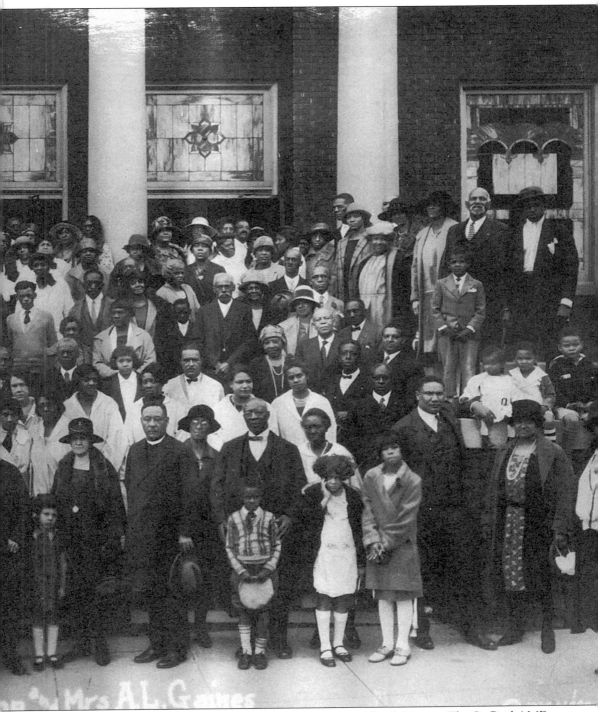

Jefferson Mash, Mary Mash, Dudley Miller, G.W. Turner, and Sarah Turner. The St. Paul AME congregation is pictured here during a visit by Bishop and Mrs. A.L. Gaines in the late 1920s. (Courtesy of E. Hobart De Patten. Photo by Sarwin Photo.)

55

This is the 1882 building of St. Paul AME Church. (Courtesy of E. Hobart De Patten.)

The 1906 building of St. Paul AME Church is pictured here. (Courtesy of E. Hobart De Patten.)

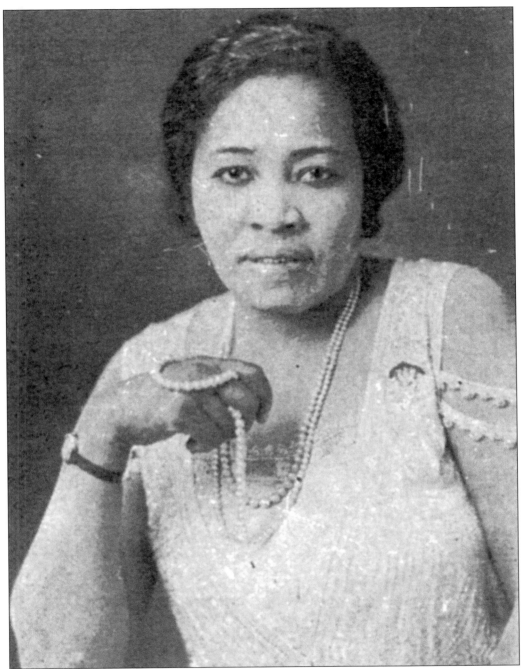

Susan M. Brown, past president of the Iowa Association of Colored Women's Clubs, was born in 1877 in Virginia. However, at an early age she moved with her parents to Buxton, where her dad worked as a coal miner. They later moved to Des Moines. Her involvement in the AME church led her to become a prominent, nationally known leader in religious, political, fraternal, and civic organizations. She was the wife of National Bar Association founder and attorney S. Joe Brown. Susan died in 1941. (Courtesy of E. Hobart De Patten.)

PROGRAM

REGION IV
LEADERSHIP TRAINING CONFERENCE
NATIONAL ASSOCIATION
... for ...
THE ADVANCEMENT OF COLORED PEOPLE

Mid-West Regional Conference
April 10-11-12, 1953

Willkie House
900 West 17th Street
Des Moines, Iowa

WALTER WHITE, Executive Secretary
WILLIAM CRATIC, Mid. West President
WILLIAM L. BELL, President
Des Moines Branch

REGISTRATION: Mrs. Herschel E. Hubbard
PLACE: James B. Morris, Jr.
FOOD PREPARATION: Mrs. Charles L .Strange
ENTERTAINMENT: Mrs. J. W. Mitchell
HOUSING: Mrs. Guy E. Greene
PROGRAM: Leland Ahern

PROGRAM COMMITTEE
Wm. L. Bell, Luther T. Glanton, Jr., Mrs. Clifford Bayles, J. B. Morris, Sr.,
George Wells, Leland Ahern, Mrs. Frederick J. Weertz.
PUBLICITY: Mrs. Guy E. Greene.

This is a cover of the program from the 1953 leadership training conference for the National Association for the Advancement of Colored People (NAACP). This Midwest regional conference was held in the Willkie House, which began as the Colored Community Center in 1926. (Courtesy of E. Hobart De Patten.)

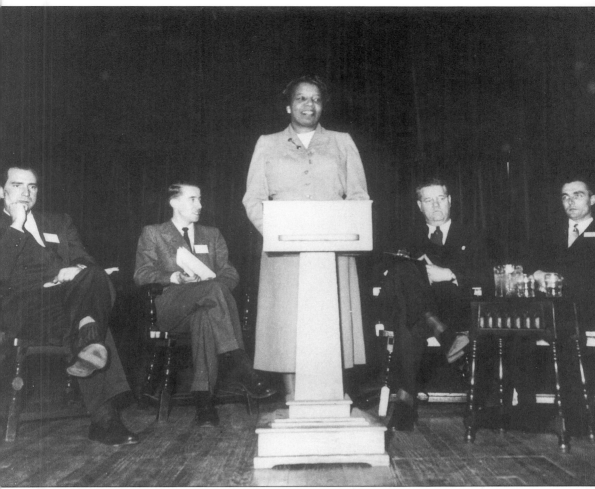

Mary Elizabeth Wood—educator, social worker, and YWCA (Young Women's Christian Association) administrator—was born in 1902 in Des Moines. She graduated from East High in 1920 and from Drake University in 1924, the only African American in her graduating class at each institution. She taught for a year at Houston (Texas) College before becoming the director of a youth program with the African-American branch of the YWCA in Tulsa, Oklahoma. Her career with the YWCA would take her to Denver, Newark, and Philadelphia before becoming executive director of the YWCA of Buffalo and Erie County, New York in 1957. She was the first African-American woman to hold such a post. She retired in 1972, after serving as executive director of the YWCA of Greater Pittsburgh. In 1996, Wood was inducted into the Iowa Women's Hall of Fame. This photograph shows Mary Wood at a speaking engagement in 1953. (Courtesy of Iowa Women's Archives, University of Iowa Libraries.)

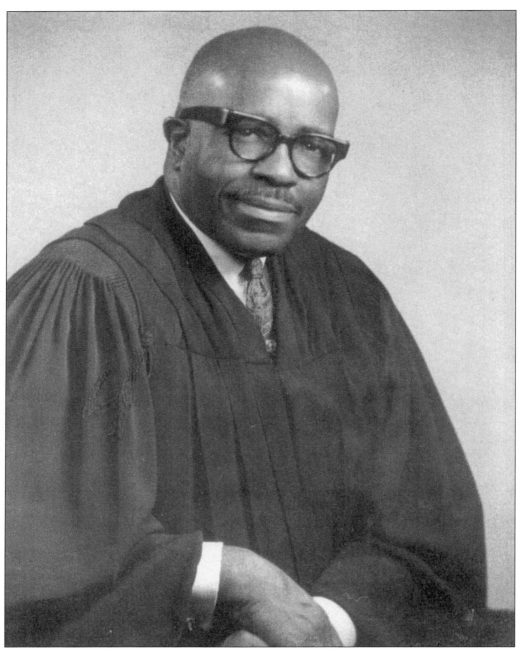

Since 1939, Luther T. Glanton Jr., the first African-American judge in Iowa, lived in Des Moines. He served a total of 32 years as a judge, beginning with his appointment in 1958 to municipal court by former Iowa governor Herschel C. Loveless. A graduate of Tennessee State University and Drake University Law School, Glanton retired as a senior district court judge. He died in 1991. (Courtesy of Willie Stevenson Glanton.)

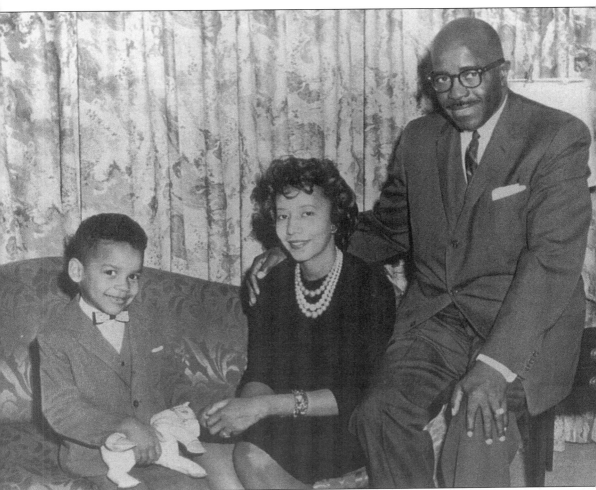

Pictured left to right are: son Luther III, wife Willie Stevenson, and Judge Glanton. The photo was taken early in 1962, just before Glanton and his wife took a trip to Africa and the Far East as goodwill ambassadors for the U.S. State Department. (Courtesy of Willie Stevenson Glanton.)

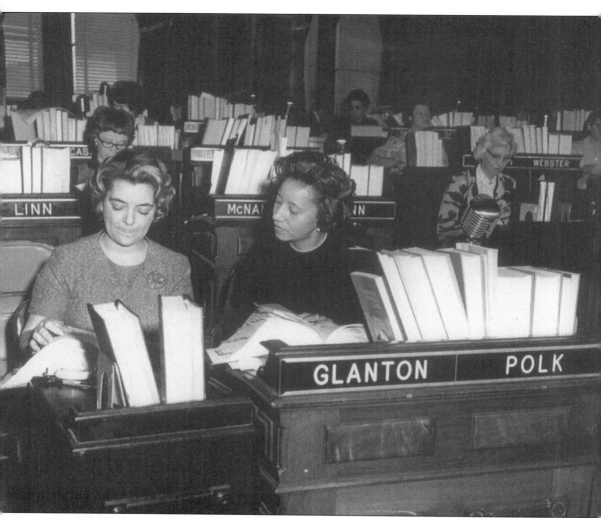

In 1965, Willie Stevenson Glanton became the first African-American woman to serve in the Iowa Legislature. In 1966, she became the first African American to be appointed attorney for the U.S. Small Business Administration. (Courtesy of Willie Stevenson Glanton.)

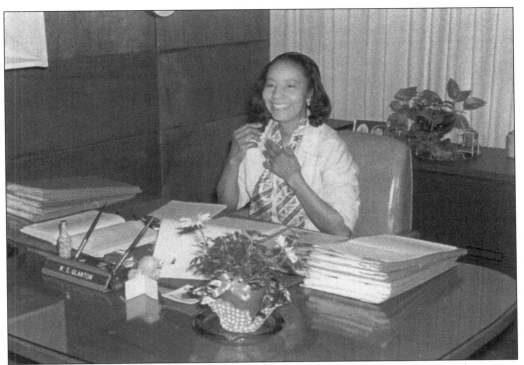

Willie Stevenson Glanton, attorney, is pictured in her Des Moines office when she was in private practice in the early 1960s. She was inducted into the Iowa Women's Hall of Fame in 1986. (Courtesy of Willie Stevenson Glanton.)

Willie Glanton, as president of the Iowa Chapter of the Federal Bar Association, is pictured (on left) with an unidentified associate in 1985. (Courtesy of Willie Stevenson Glanton.)

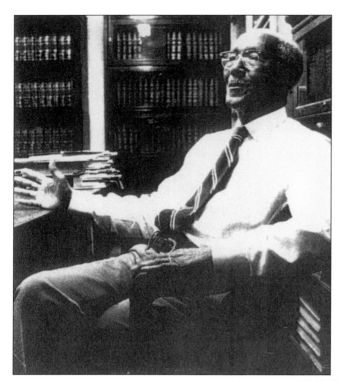

James B. Morris Sr. (1890–1977) was publisher and editor of the *Iowa State Bystander* from 1922 to 1972. Founded in 1894 by W. Williamson, B. Colson, and J. Logan, the *Bystander* was the first African-American weekly newspaper west of the Mississippi. Morris provided positive news to Iowa's blacks and mobilized community support for issues and projects that affected African Americans locally and nationally. The *Bystander* was eventually sold in 1972. Morris, a practicing attorney for over 50 years, was also one of the founders of the National Bar Association. A World War I veteran, he completed the colored officer training program at Fort Des Moines. (Courtesy of Robert V. Morris/Morris Collection.)

Robert E. Patten (1883–1968), printer and salesman, moved to Buxton from Georgia around 1900. He relocated to Des Moines in 1909. Patten opened his print and photography shop on Fourteenth Street in the Center Street neighborhood. He hoped to open a museum to display the items that he printed for the African-American Des Moines community. Patten never did open his museum. However, his printing legacy is the focus of an exhibit at the State Historical Society of Iowa in Des Moines. (Courtesy of E. Hobart De Patten.)

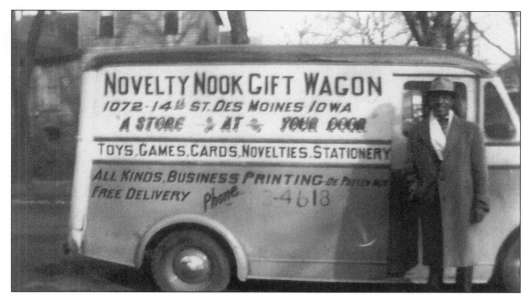

From the time that he was a small child, Hobart assisted his dad in his business. As an adult he entered into several business ventures. Here he is pictured in front of his Novelty Nook sales vehicle. (Courtesy of E. Hobart De Patten.)

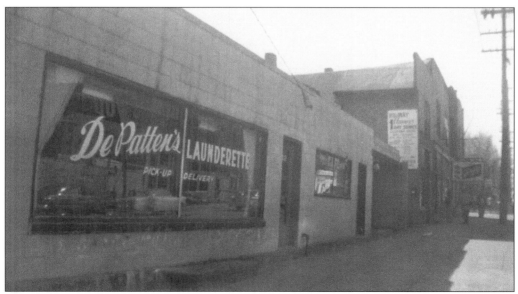

Hobart also owned a launderette. (Courtesy of E. Hobart De Patten.)

(Column K)

DRUG STORES AND PHARMACIES

COMMUNITY PHARMACY, Mr. J. W. Mitchell, Prop. Special attention given to our prescription department. 1200 Center Street, Phone 3-9860.

McLAINE, MORRIS P., (Community Pharmacy). A licensed Pharmacist. 1200 Center Street, Phone 3-9860.

WALKER STREET PHARMACY, Mr. Harry W. Hammitt, Prop., 1554 Walker Street, Phone 6-1875.

DENTISTS

RITCHEY, DR. WM. J., 517 Mulberry Street, Phone 3-8411.

WILLIS, DR. L. R., 205 Watrous Building, 6th Avenue and Mulberry Street.

DRESS DESIGNING MODISTE

MRS. JAMES OTIS, 1169 14th Street, Phone 7-4705.

MORRIS, MRS. GEORGINE C., 955 17th Street, Phone 4-7776.

FANT, MRS. GOLDIE, 1654 Walker Street, Phone 6-5242.

(Column L)

EXTERMINATION AND FUMIGATION

THE UNEEDOR CHEMICAL COMPANY, Mr. Lawrence J. Chapman, owner. We offer complete exterminating service for all household insects, and use gas indorsed by U. S. Government. We Moth-Proof. 3005 3rd Street, Phone 3-5068.

FUNERAL HOMES

ESTES FUNERAL HOME, John M. Estes, Mortician and Director. Home completely remodeled. Our own complete rolling stock. Lady attendant. 811 14th Street, Phone 3-5944.

L. FOWLER AND SON. "Funeral Home Beautiful." One of the Oldest and Best equipped Funeral Homes in the Middle West. 1701 Walker Street, Phone 6-2713.

GARAGES

SAUNDERS AUTO REPAIR, John Saunders, Prop., 1306 Day Street.

TUCKER & CARTER PAINT & BODY SHOP. Tucker and Carter, Props. 20 years of experience in gendrecks. 2443 Des Moines Street, Phone 6-4446.

WARRICK AUTO SERVICE, F. B. Warrick, Prop. General service, battery repairing and service, oil, tires, glass installed, ignition, starter and generator repairing, body and fender work. We specialize in brake service. 22 years experience on all makes of cars. 1320 E. 18th St., Phone 6-2553.

John Estes Sr., licensed mortician, established Estes Funeral Home in 1917. Later his son, John Estes Jr., joined his father in business, taking it over in 1971. In 1995, the business underwent a name change to Estes-Nichols Chapel. Pictured here is a page from the Des Moines 1939–1940 Negro Business and Information Directory. Note that Fowler and Son Funeral Home is no longer in business today. (Courtesy of E. Hobart De Patten.)

Pictured is Ruth Ann Gaines at age eight. In 1998, Des Moines native Gaines became the first African-American recipient of the Iowa Teacher of the Year award and a finalist for the National Teacher of the Year award. (Courtesy of Ruth Ann Gaines.)

Ruth Ann Gaines is pictured here at age 22 as a theater arts graduate of Clarke College. She lived in California for a short time before returning to Iowa and beginning her teaching career in the 1970s. (Courtesy of Ruth Ann Gaines.)

In 1998, Richard S. White retired from John Deere Company as the first African-American General Manager of the company. He began his career in 1963, after a three-year stint with the U.S. Army medical corps. In 1996, he was inducted in the Junior Achievement section of the Central Iowa Hall of Achievement. (Courtesy of Richard and Barbara White.)

Pictured here is the White family on their 1987 vacation in Hawaii. Left to right are: (seated) daughters Karen and Pamela, (standing) wife Barbara, and Richard. (Courtesy of Richard and Barbara White.)

Seven

FORT DODGE

Early History

Located in Webster County on the east bank of Des Moines River, Fort Dodge is home to Iowa Central Community College. William Williams was founder of the town. Originally named Fort Clark, the town was renamed Ft. Dodge in 1851 due to confusion about mail service between the new fort and an older camp. The Black population arrived from the South in this city when Reconstruction ended and the railroads opened the western plains. Most Black men worked as laborers in the local mines, mills, and rail yards.

African Americans lived in each of the city's four wards, but mainly in an area known as Pleasant Valley or the "Flats." The "Flats" was the area between the Illinois Central Railroad tracks and the Des Moines River, extending from Central Avenue to the Coleman District. The families living there were known as "Flat Rats." After the 1940s and 1950s floods, the original "Flats" were turned into a golf course.

A second wave of migration from the South after the Korean War doubled the African-American population in the city. Around the 1960s, community leaders began to campaign against discrimination especially in education, housing, and employment. The campaign would result in the establishment of a Human Rights Commission and an urban renewal program that would improve the living conditions of Fort Dodge's largest minority community. According to the 1990 U.S. Census, African Americans make up 2.5% of the Fort Dodge population.

TOTAL POPULATION: 25,894 (1990 CENSUS)
AFRICAN-AMERICAN POPULATION: 661 (1990 CENSUS)

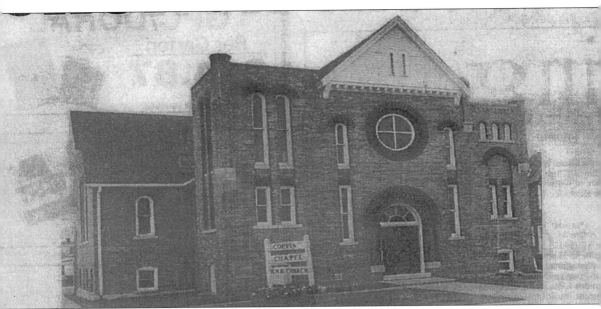

A group of Methodists from Missouri founded Coppin Chapel African Methodist Episcopal (AME) in the spring of 1915. The congregation first met in a building at First Avenue and Fourth Street. After several moves throughout the city, the members finally secured a building that was formerly home to Calvary Baptist Church and St. Olaf Lutheran Church. Pictured is Coppin Chapel at its present location on First Avenue South. The cornerstone was laid in the spring of 1969, and the mortgage was retired in 1978. In 1988, the Rev. Jesse L. Jackson made a campaign appearance at Coppin Chapel during his bid for the Presidency of the United States. (Courtesy of William C. Perkins Sr.)

Pictured are William and Rose Perkins, longtime residents of Waterloo. Rev. Perkins has been pastor of Coppin Chapel AME since 1981. (Courtesy of William and Rose Perkins.)

A lifelong resident of Fort Dodge, Jane Burleson was employed with Hormel & Company for 33 years, retiring in 1981. In 1982, she became a para-professional in the Fort Dodge school system. Her many labor union, civic, church, political, and community activities led her to become the first woman and first African American elected to the Fort Dodge City Council in 1982. She is currently the senior council member. Pictured is Burleson, with Dick Gephardt, at a Democratic function. (Courtesy of Jane Burleson.)

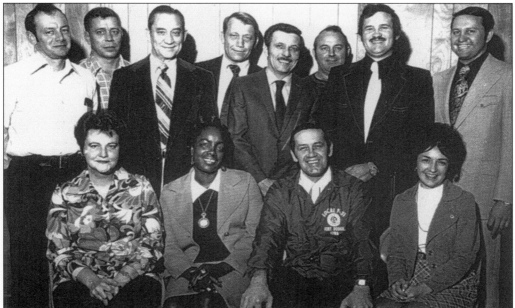

Jane Burleson is seated (second from left) with leaders of Local 31, United Packinghouse Workers of North America. Her involvement as recording secretary and member of various committees caused her to also be active in the Webster County Federation of Labor. (Courtesy of Jane Burleson.)

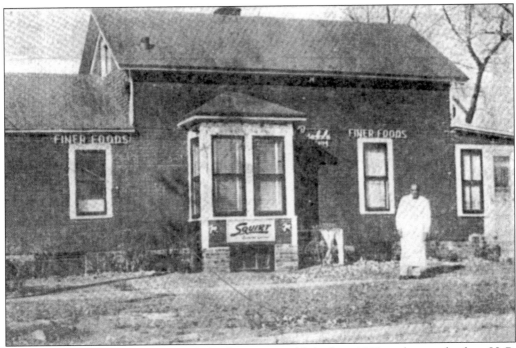

The Harry Clifton Meriwether Scholarship was established in 1982 to honor the late H.C. Meriwether (pictured). He was one of the first African Americans to own and operate a business, called Harry's Chicken Shack, in the city. Most people remembered Meriwether not only because of his business abilities, but also because of his leadership skills in trying to help the Black community. Today a street in the "Flats" is named in his honor. (Courtesy of Judge Brown and Mary Wilkins.)

In 1986, Judge Brown, a teacher, became the first African American on the Fort Dodge Community School Board. (Courtesy of Judge Brown. Photo by Haase Photography.)

Eight

IOWA CITY

Iowa City was founded in 1838. It became the home of the state's first capital in 1846, and the University of Iowa in 1847. As a result of attending the University of Iowa, many African Americans have been able to take advantage of educational, professional, and athletic opportunities throughout the world. However, a few stayed to become part of the local Black community. The African-American residents in the community who were not affiliated with the university had dwindled to a very small number and were spread throughout the city. Although the capitol moved to Des Moines, Iowa City flourishes because of its teaching hospitals and medical complexes, internationally-known writing community, and a host of diverse cultural, artistic, and recreational opportunities. According to the 1990 U.S. Census, African Americans make up 2.5% of the Iowa City population.

TOTAL POPULATION: 59,738 (1990 CENSUS)
AFRICAN-AMERICAN POPULATION: 1,492 (1990 CENSUS)

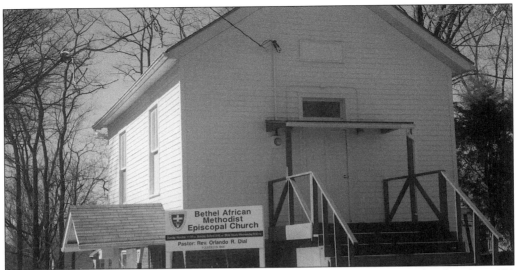

Bethel AME has been a part of the community since 1868. Pictured here is the church at 411 South Governor Street, where the congregation has met for over one hundred years. The building was outside the original city lines because Black people were not allowed to own property within the city limits at that time. James W. Howard, Boston Clay, and Samuel Boone were three of the original trustees. City directories from 1892 to 1902 referred to the church as Zion's AME. After 1906, it was consistently called Bethel. (*Courtesy of Waterloo United Communicator*. Photo by Charline Barnes.)

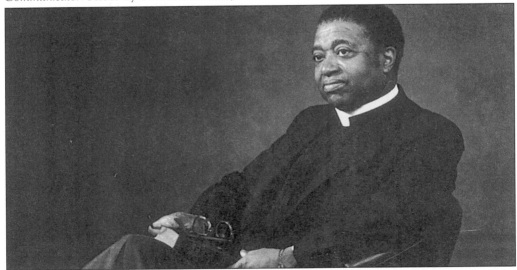

During the years 1900 to 1950, pastoral assignments changed regularly. Although the membership was small, physical improvements to the church and parsonage occurred during this time. With a wife and six children, Rev. Fred L. Penny (pictured) came to Bethel AME in 1958. During his 37 years as pastor, Rev. Penny provided an open door for African-American students attending the University of Iowa. After Sunday services, meals were served with stimulating conversations on various social issues of the times. In September 1994, nearly four decades of students, church members, and the community of Iowa City mourned the death of Rev. Fred Penny. (Courtesy of Dianna Penny.)

Elizabeth (Bettye) Crawford Tate was born in Fairfield, Iowa, in 1906. She graduated from the local high school in 1926. In the 1930s, Bettye married Junious (Bud) Tate and moved to Iowa City. The Tates were one of a few African-American families in Iowa City. Bud operated a janitorial service that catered to downtown stores. Bud and Bettye were divorced in 1963. Bettye Tate worked for 22 years at the University of Iowa Hospital's cardiovascular lab, beginning as a clinical technician and retiring in 1976 as a supervisor. Her two hobbies were traveling and acting. She has traveled all over the world. As a charter member of the Iowa City Community Theatre, Bettye sold advertising, served on the board of directors, and performed in various productions. Betty is pictured here at 90 years old in 1996. (Courtesy of Bettye Tate.)

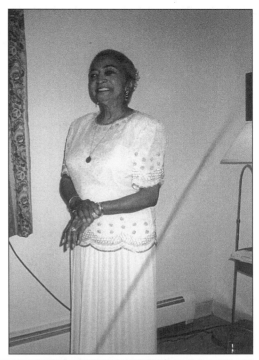

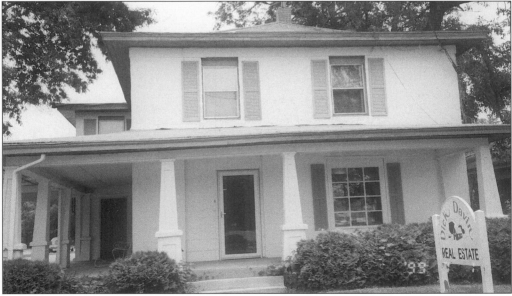

In the early 1940s, the Tates purchased a 12-room house at 914 South Dubuque Street, where they opened their home as a boarding house for Black students. At that time, African-American students were not allowed to live in university housing. "Tate Arms" housed up to 20 tenants at a time. It remained in operation for over 30 years. The house was sold and converted to an office building for a real estate company. The stately porch and portico still stand, but the brick exterior has been covered with white stucco. (Courtesy of *Waterloo United Communicator*. Photo by Charline Barnes.)

The Black Women's Club of Iowa purchased a house at 942 Iowa Avenue, so that the out-of-town Black female students could have a place to live. Pictured here is Mrs. Lowry, who served as housemother. (Courtesy of Phil Hubbard.)

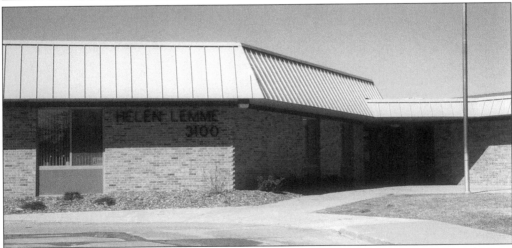

Frances Helen Renfrow Lemme, a civil rights and community leader in Iowa City, was born in 1905 in Grinnell, Iowa. She graduated in 1928 from the University of Iowa. She married Allyn in 1929, and worked as a research technician in the Department of Internal Medicine at the University of Iowa. The Lemme family opened their home at 603 South Capitol Street as a sanctuary to the Black students attending the University of Iowa. In 1955, Helen was elected as Iowa City's first Woman of the Year. She died in a house fire in 1968. Pictured here is the Helen Lemme Elementary School in Iowa City, which opened in 1970 in her honor. (Courtesy of *Waterloo United Communicator*. Photo by Charline Barnes.)

Dr. Philip G. Hubbard tells his life story, including his advancement from student, to teacher, to administrator at the University of Iowa, in his book called *My Iowa Journey: The Life Story of the University of Iowa's First African American Professor*. Here he is pictured in his office in the old capitol as the newly appointed University of Iowa's Dean of Academic Affairs. (Courtesy of Phil Hubbard.)

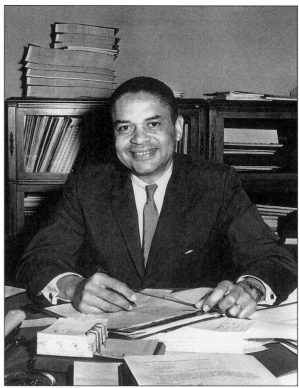

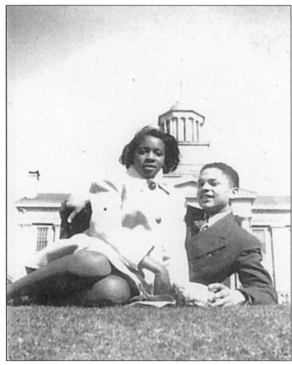

In 1925, Philip G. Hubbard, as a young boy, moved to Des Moines from Missouri. This is where he met his wife, Wynonna Griffin, who was born in Valley Junction (now West Des Moines). Pictured are the Hubbards on the grounds of the old capitol in Iowa City. (Courtesy of Phil Hubbard.)

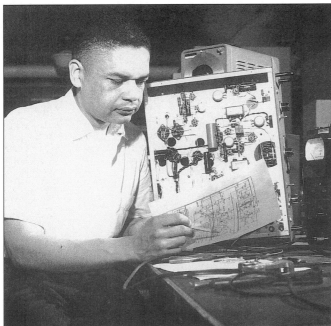

Philip G. Hubbard graduated from the University of Iowa with a degree in electrical engineering in 1946 and received his Ph.D. in 1954 from the same institution. He is pictured here in 1951 with the hot-wire anemometer that was the subject of his doctoral research. (Courtesy of Phil Hubbard.)

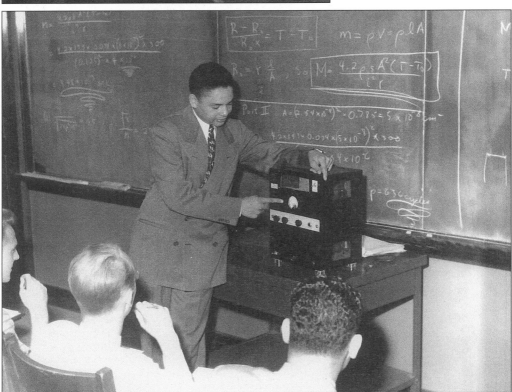

Here is Dr. Hubbard lecturing about the hot-wire anemometer at the University of Iowa in 1965. (Courtesy of Phil Hubbard.)

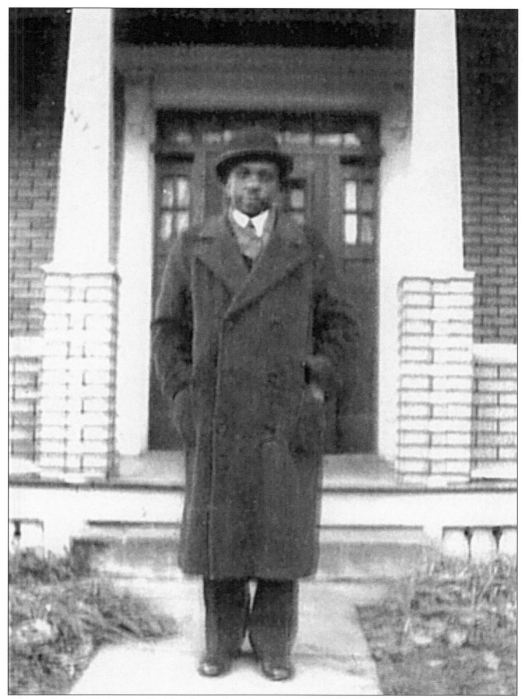

Although Dr. Philip G. Hubbard was hired as the first African-American professor at the University of Iowa, Dr. Rev. Thurman (pictured) was the first Black guest professor to teach at the university. He was a visiting faculty member in the School of Religion. (Courtesy of Phil Hubbard.)

Ted Wheeler, a former all-American athlete, came to Iowa in 1950 on an athletic scholarship. He received his degree in 1957, and after working in Chicago for a few years, he returned to his alma mater in 1972 as an assistant track coach. He became the University of Iowa's Head Track Coach from 1978 to 1996. Here is Coach Wheeler with Dennis Green, Head Coach of the Minnesota Vikings and a graduate of the University of Iowa. (Courtesy of Ted Wheeler.)

Pictured with Coach Wheeler is 1996 Olympian participant and 1994 Iowa graduate Anthuan Maybank and Dick Summerwell, president of Iowa State Bank in Iowa City. (Courtesy of Ted Wheeler.)

Nine

SIOUX CITY

Early History

Sioux City is a northwest town located on the banks of Missouri, Sioux, and Floyd Rivers. This geographic area is where Nebraska, South Dakota, and Iowa meet. From its beginnings, steamboats made Sioux City a regular port of call. At the beginning of the twentieth century, Sioux City was christened "Little Chicago" in the West because of the "Big Three" packinghouses: Cudahy, Armour, and Swift. Blacks first settled in the low-priced, multi-dwellings near the Missouri River and the railroad tracks. Gradually they established successful businesses along Seventh Street, northwest of downtown. However, unskilled laborers comprised the highest percentage of the African-American labor force in the early development of Sioux City.

In the early 1900s, Rev. J.C. Reid of Mt. Zion Baptist Church served as an advocate for his people by publicly discussing the "race question" and objecting to the dramatization of demeaning minstrel performances that White actors in "blackface" make-up did to portray plantation slaves as untutored, simple, docile, and manageable. The black socioeconomic hierarchy would undergo rapid change due to the entry of African Americans into the local meatpacking industry, where they were used as strikebreakers. Many of these Black workers settled in the low, working-class district called the "South Bottoms," which was close to the meatpacking plants. The laborers measured their economic status by their ability to move to older, established residential areas on the west side of town. According to the 1990 U.S. Census, African Americans make up 2.5% of the Sioux City population.

TOTAL POPULATION: 80,505 (1990 CENSUS)
AFRICAN-AMERICAN POPULATION: 1,993 (1990 CENSUS)

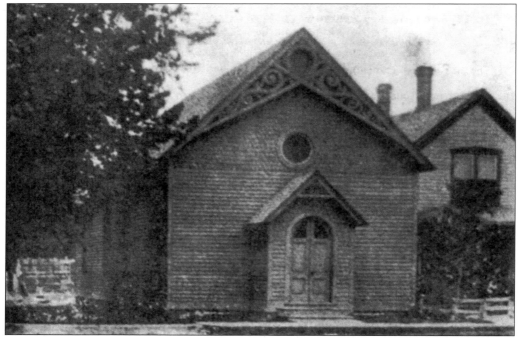

The African Methodist Episcopal (AME) Church was established in 1883 on the corner of Third and Court Streets. Land was purchased, and a church building (pictured) placed on Main Street between Fifth and Sixth Streets. In 1916, the church was named Malone AME after the presiding bishop. (Courtesy of Lillian Fletcher/Malone AME Church.)

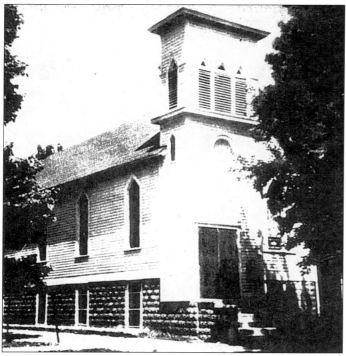

At the turn of the century, the building shown here was built on what was previously the site of the Main Street church. The congregation continues to meet in this building. However, urban renewal in the 1970s changed the outside structure of the Malone AME Church. (Courtesy of Lillian Fletcher/Malone AME Church.)

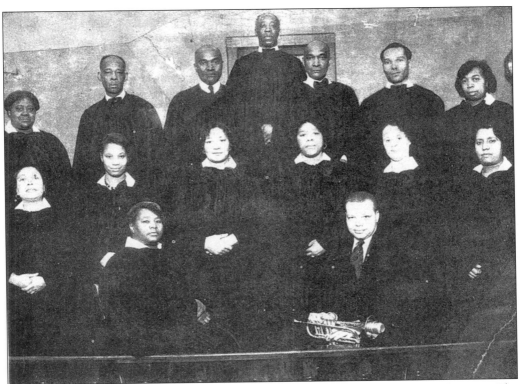

Taken in 1931, this picture portrays one of the best-trained church choirs of that era. The members of the Malone AME Church Choir, from left to right, are: (front row, seated) organist Lena Thomas and trumpeter Fleming Brown; (second row) Mrs. Mansfield Askew, Mrs. Lucile Brown, Mrs. Arizona Trice, Mrs. J.W. Workcuff, Mrs. Phalbia Boyd, and Mrs. Effie Majors; (back row) Mrs. Henrietta Daniels, Pearl Rothwell, Ed Askew, Albert Williams, Mansfield Askew, Mr. Brown, and Mrs. Rothwell. (Courtesy of Lillian Fletcher/Malone AME Church.)

Pictured is Prince Henry Yates, pastor of Malone AME Church in 1961. He was also a longtime businessman who owned and operated a café. A teen club met for many years at his café. (Courtesy of Lillian Fletcher/Malone AME Church.)

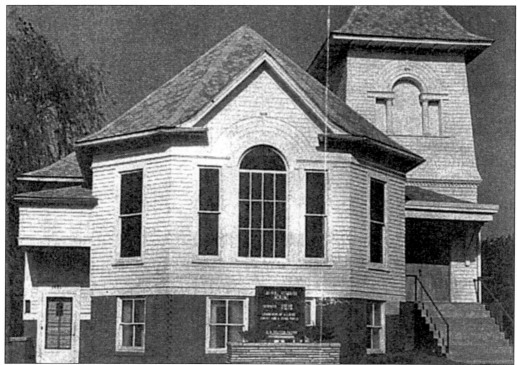

Although Mt. Zion Baptist Church's beginnings date all the way back to 1887, it was formally organized on October 8, 1900, as the first African-American Baptist Church in Sioux City. The church was incorporated in 1902, and the building at West Sixth and Bluff was purchased. On June 26, 1932, the congregation marched to its present location at 1421 Geneva Street (pictured). (Courtesy of Verona Cook Trosper/Mt. Zion Baptist Church.)

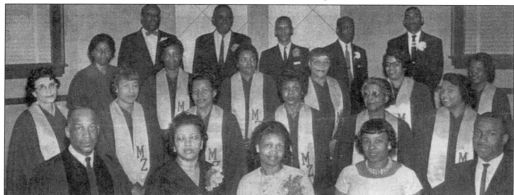

Pictured here are members of the 1962 Mt. Zion Baptist Church choir. From left to right are: (front row) Rev. E.W. Bratton (pastor), Mrs. E.W. Bratton (organist), Mrs. Louis Garland (pianist), Mrs. Elizabeth Hayes (pianist), and Capt. I.W. Mincy (director); (second row) Mrs. Classie Brown, Mrs. Etta Grider, Mrs. Willie Winfrey, Mrs. Jane Davis, Mrs. Olivia Bolton, and Mrs. Betty Mincy; (third row) Mrs. Fannie Alexander, Mrs. Viola Banks, Mrs. Lorine Hayes, Mrs. Maxine Anderson, Mrs. Carolyn Moon, and Mrs. Earldean Hunter; (back row) Mr. Louis Garland, Mr. Archie Shelby, Airman Clifton Hall, Mr. Louis Brown, and Sgt. William Matthews. (Courtesy of Susan Fenceroy/Mt. Zion Baptist Church.)

Both Olivia Bolton (b. 1900), top, and her daughter, Leona Fields (1918–1998), have been active members of Mt. Zion Baptist Church. (Courtesy of Susan Fenceroy.)

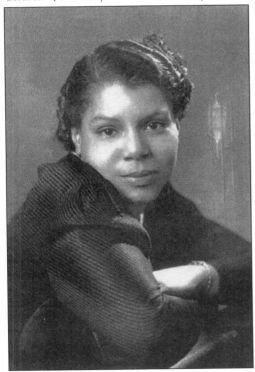

During World War II, Leona's husband Richard served in the U.S. Army. Here he is pictured in his uniform with members of his family. From left to right are: Maude Harriet, Richard, Leona, Riley (Richard's brother), and Maude Marsh (Richard's mother). Three unidentified children stand in front of the adults. (Courtesy of Susan Fenceroy.)

Taken on February 8, 1944, this picture shows Richard Fields (third row, first person on right) with fellow soldiers. (Courtesy of Susan Fenceroy.)

The Sanford Community Center on Geneva Street, between Seventeenth and Eighteenth Streets, was built by Arthur and Stella Sanford at a cost of $100,000 as a social place on the west side to further interracial understanding and better community living. (Courtesy of Harriett Trosper Bluford.)

Dedication Program

SUNDAY, JUNE 17, 1951—3:00 P. M.

Entrance of Color Guard	POST 697, AMERICAN LEGION
Singing "Star Spangled Banner"	Audience led by MRS. PAULINE McKAY
Invocation	REV. H. R. BOSTON
Remarks by Chairman	ARTHUR HAYES
Presentation of Building	ARTHUR SANFORD
Acceptance of Building by President of Sanford Center	ARTHUR HAYES
Acceptance on Behalf of City	HON. DAN J. CONLEY
Acceptance by Chairman of Community Fund Board	DUANE KIDDER
Remarks by Representatives of Youth Groups	CURTIS HAYES and JO ANN BAKER
Solo	MRS. IVA TOWNES
Introduction of Hon. Guy M. Gillette	ARTHUR SANFORD
Dedication Address	HON. GUY M. GILLETTE, United States Senator
Negro National Anthem	Audience led by MRS. PAULINE McKAY
Benediction	RABBI S. BOLOTNIKOV

Following adjournment of Dedication program, the audience is invited to tour the building.

Board of Directors of Sanford Center

Arthur Hayes_____President	Henry Kendrick_____Business Manager
Mrs. Letha Nevings_____Vice President	Louis Brown_____Program Chairman
Mrs. Arretta Butler_____Secretary	Mrs. Beulah Webb___Hospitality Chairman
Roosevelt Pettaway_____Assistant Secretary	Mrs. Elzona B. Trosper___Executive Director
Louis Carter_____Treasurer	Mary J. Treglia_____Advisor
Oscar Nevings____Chairman Finance Com.	Mr. and Mrs. Arthur Sanford —Honorary Members

Pictured here is a copy of the dedication program of Sanford Community Center on June 17, 1951. The Honorable Guy M. Gillette, United States Senator, gave the dedication address. (Courtesy of Harriett Trosper Bluford.)

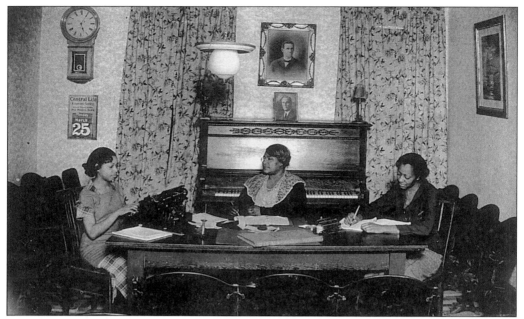

The Sanford Center is the successor to the Booker T. Washington Center, located at 722 1/2 West Seventh Street. Stella Sanford founded Washington Center in 1933 for Sioux City's African-American community. Seated in the middle is Lena N. Thomas, the first administrator of the Washington Center. (Courtesy of Harriett Trosper Bluford.)

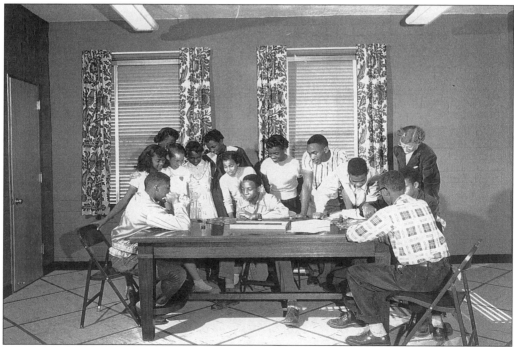

Unidentified teens are seen here with a volunteer at the Sanford Community Center. (Courtesy of Harriett Trosper Bluford.)

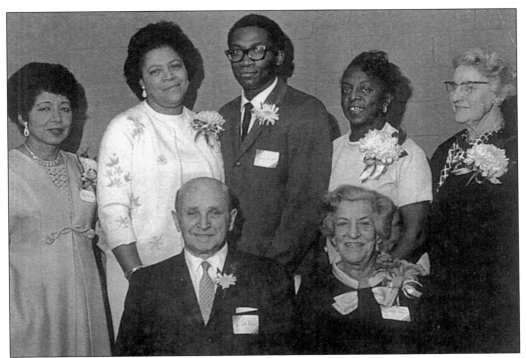

Elonza B. Trosper was the first executive director of the Sanford Community Center. She was a lifelong leader in the civic and social affairs of the west-side community. Both she and Mabel Hoyt promoted self-help to people regardless of their cultural, ethnic, or economic backgrounds. Pictured from left to right are some of the 1968 board members of the Sanford Community Center: (seated) Arthur and Stella Sanford; (standing) Mabel Robinson, Arretta Butler, George W. Boykin, Elzona Trosper, and Mabel Hoyt. (Courtesy of Harriett Trosper Bluford.)

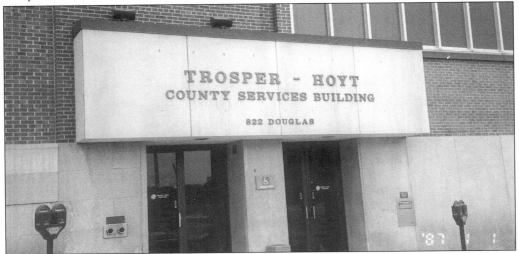

Sioux City named its County Services Building after Trosper and Hoyt, who together contributed more than one hundred years of service to the community. (Courtesy of *Waterloo United Communicator*. Photo by Charline Barnes.)

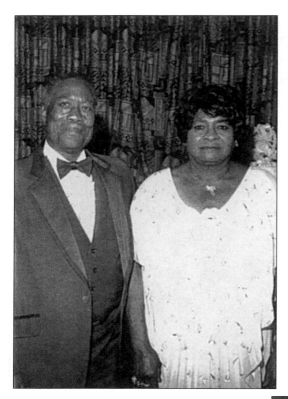

Pictured are George Sr. (b. 1910) and Louvenia (b. 1913) Boykin at their 50th wedding anniversary in 1979. The Boykins arrived in the Siouxland area from Mississippi in the early 1930s on their way to Chicago, where jobs were plentiful. Liking the area and being close to family members, the elder Boykins stayed to raise seven children. Although he worked as a meat packinghouse employee, George Sr. became a Methodist minister and led Malone AME Church in Sioux City for several years. (Courtesy of George W. Boykin.)

Financial strains on his family caused George W. Boykin, executive director of the Sanford Community Center for over 25 years, to leave Nebraska Wesleyan. George later re-entered college. He attended Morningside College (Iowa), where he graduated with a degree in sociology in 1971. He met his wife Michele there, and they had one son, George Jr., and two daughters, Jennifer and Courtney. (Courtesy of George W. Boykin. Photo by Tod's Photos.)

Recipient of many community awards, George W. Boykin, a native of South Sioux City, was the first Black elected to the Sioux City Community School Board, and he held that position for three terms (1971–1983). The school district was the first to have its Affirmative Action Plan approved by the state in 1972. In 1985, George became the first African American elected to the Woodbury County Board of Supervisors. He is currently serving his fourth term. Pictured left to right are George and his friend Grady Bluford. (Courtesy of Harriett Trosper Bluford.)

Pictured here is Beulah Webb, who was founder of Siouxland (Iowa) Senior Center. Webb moved to Sioux City in 1924 and worked for better housing, schools, and social resources for Blacks and Whites alike. She died in 1998 at the age of 102. (Courtesy of Leah J. Bryson.)

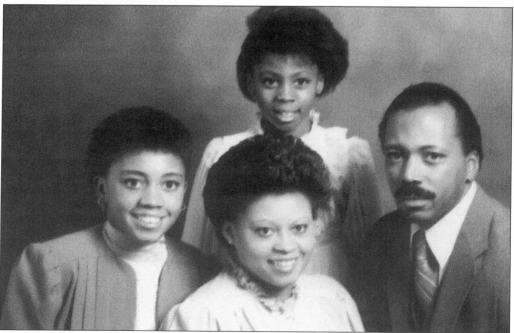

The Lee Family, from left to right, are: Treyla, Flora, and Rudy. Standing is Marissa. The youngest child, Trenton, is not pictured. In 1983, Rudy became the first and only African-American firefighter in Sioux City. He is also the first Black licensed electrician in the area. Flora became the first Black female to be elected to the Sioux City Community School Board. Since 1991, she has served three terms and is currently board president. (Courtesy of the Flora Lee.)

Ten

WATERLOO

Early History

Long before the first White settlers came to the Iowa Territory, the Cedar Valley area was home to the Sauk, Fox, Meskwaki, and Winnebago tribes. In 1845, William Sturgis built a cabin along the Cedar River, and the area grew to be called Sturgis Falls (renamed Cedar Falls in 1847). On the opposite bank of the Cedar River, George Hanna established a homesite in 1845 that was named Waterloo. In 1855, it became the county seat of Black Hawk County and lies in the northeast corner of the state.

The Illinois Central Railroad (ICRR) reached the Cedar Valley area in 1861. Most early Black residents came to Waterloo as a result of the Illinois Central Railroad (ICRR), which had recruited and transported them to break the strike caused by its White workers. These early African-American, southern workers lived in boxcars provided by their employer. When the men were later joined by their wives and children, the area near the ICRR shop, Sumner to Mobile Streets, grew to be known as the African-American Historic Triangle, approximately 20 square blocks, because of a local housing covenant that restricted African Americans and other ethnic groups from renting or purchasing a home in certain areas.

Since the early 1900s, Waterloo's Black community has mainly been employed by the railroad, meatpacking, and agricultural-engineering industries. The African-American community's involvement in the Civil Rights Movement brought about some growth in political freedom, social dignity, and economic advancement in Waterloo. Today, the Cedar Valley area has become a major agricultural, industrial, and service center. According to the 1990 U.S. Census, African Americans make up 12% of the Waterloo population.

TOTAL POPULATION: 66,467 (1990 CENSUS)
AFRICAN-AMERICAN POPULATION: 8,077 (1990 CENSUS)

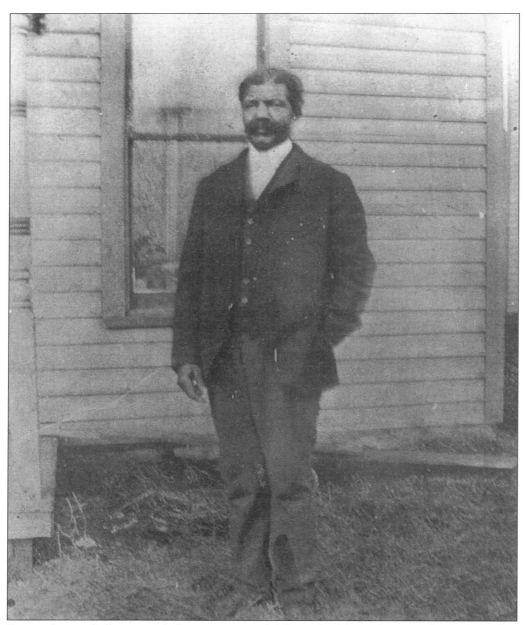

During the antebellum period, there were several African Americans living in the Cedar Valley area. Pictured is North Carolina native and former slave George R. Warn, who, in 1865, came with some Union soldiers to Illinois. He was later adopted and raised by the Jamisons, a White family that lived in Waterloo. Warn (the spelling was changed to Warren) married Sarah Jane Suter in 1883. George and Sarah Warren settled in Waterloo for a short while, but then became one of the first Black families to reside in Marshalltown, Iowa. (Courtesy of Helen Warren Johnson.)

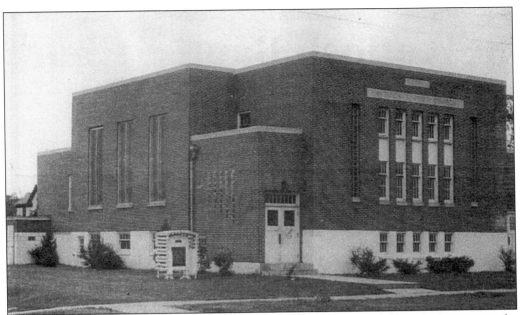

Antioch Baptist, as one of the oldest Black churches in Waterloo, has served the community for over 80 years. From a prayer band of about 15 people, Rev. Samuel Bates, Rev. J.M. Reynolds, and Rev. Burton organized the band into a church in April 1913. In 1914, the McFarlane School, located at 601 Douglas Street, was purchased and became the church's first home. In 1951, the congregation moved to the present location (pictured) at 426 Sumner Street. (Courtesy of Michael E. Coleman/Antioch Baptist Church.)

Antioch had approximately 1,400 worshippers when, in the 1960s, they added an 18-room education wing. By the early 1980s, the membership had grown to make it the largest Black congregation in the state of Iowa. The members added a sanctuary and a fellowship hall in 1981 (pictured). Besides building a church, Antioch Baptist has been instrumental in establishing the People's Community Health Clinic, which serves the health care needs of low-income people. (Courtesy of Michael E. Coleman/Antioch Baptist Church.)

Pictured here is Fred Webster, who has been a member of Antioch Baptist since 1931. (Courtesy of Fred Webster.)

Here is Louise Walker, a 1933 Waterloo East High graduate. In 1912, her parents, the Childers, arrived in Waterloo and were active members of Antioch Baptist. (Courtesy of Louise Walker.)

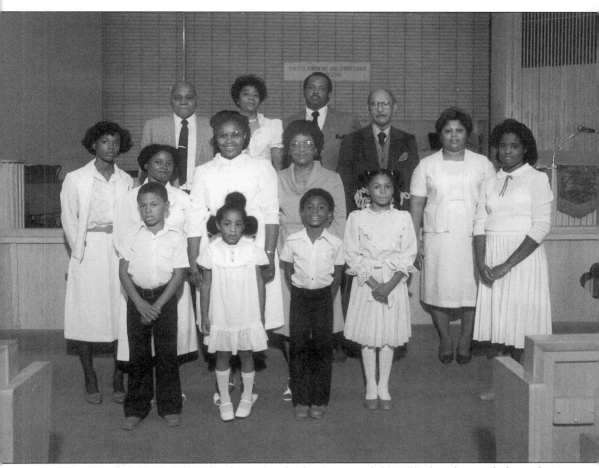

On July 12, 1914, Bess's Chapel African Methodist Episcopal (AME) church was dedicated. Its charter members were C.R. Cheatham, U.G. Smith, Sarah Cooper, Minnie West, William Pierces, Sid Cheers, Lillie Whitfield, Jesse Bess, Alex Hyland, William Amens, Carrie Bright, and Myrtle Lasley. The church has had three names: Bess's Chapel AME, Bethel AME and, finally, it was officially named after the sixth Bishop of the AME Church—Bishop Daniel Payne (1811–1893). In 1952, Rev. George Stinson Jr. launched an extensive fund drive for the building (now known as Payne Memorial AME Church) that was dedicated in 1959. Rev. Wilson O. Rideout, the current pastor, has been instrumental in increasing the membership and doubling the physical size of the church building. Pictured here is a group of members from Payne AME in 1983. (Courtesy of Floyd Bumpers.)

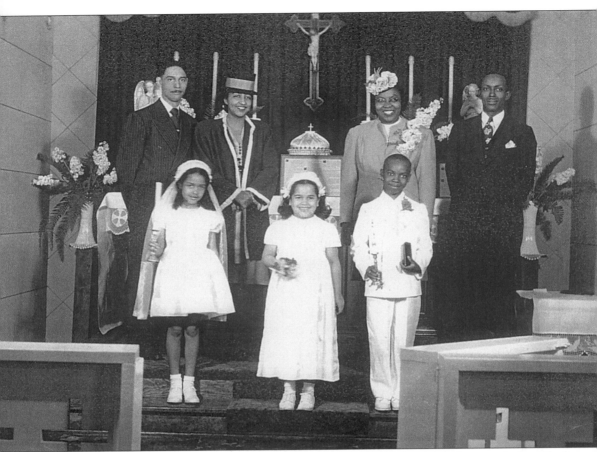

Although no longer in existence, St. Peter Claver Catholic Church served the Black community for over 25 years. The newly constructed frame church at 1112 Mobile Street (between Oneida and Sumner Streets) was dedicated in September 1940. It had approximately 50 members at that time. In 1965, St. Peter Claver parish closed due to declining membership. In 1967, Jessie Cosby Neighborhood Center was located in the former church building. Here are several children in 1947 at first communion. From left to right are: (front row) Deanna Smith, Becky Furgerson, and David Davis; (back row) parents Clifford and Lee Russell Smith, and Mr. and Mrs. Davis. (Courtesy of Becky Furgerson Sloan.)

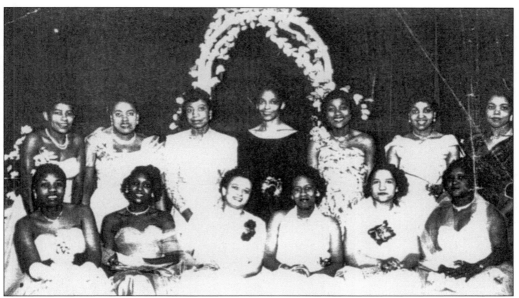

Many African-American organizations have worked at lifting the standards of the community through literary, cultural, social, and economic advancement in Waterloo. One of these organizations is Ad Loy Ho Club (Advancement, Loyalty, and Hope), founded in 1948. It was the first Black women's organization to break the "color barrier" in Waterloo by holding its 1949 banquet at the Russell Lamson Hotel. Pictured at one of its banquets, from left to right, are: (front row) Ada Tredwell, Ruth Holt, Lois Norman, Estella Haughton, Thelma Benjamin, and Delores Lee; (back row) Madelean Green, Arietta Magee, Lavora Sheppard, Audrey Penn, Leona Sallis, founder Cora Bell Haughton, and Frances Kincaid. (Courtesy of Sallie Johnson/Ad Loy Ho Club.)

Four Waterloo Women's Civic Club members are preparing decorations for its 30th anniversary celebration in 1980. From left to right are Lou Burke, Fannie Allen, Louise Walker, and founder Betty Allen. (Courtesy of Vanella Byrd/Waterloo Women's Civic Club.)

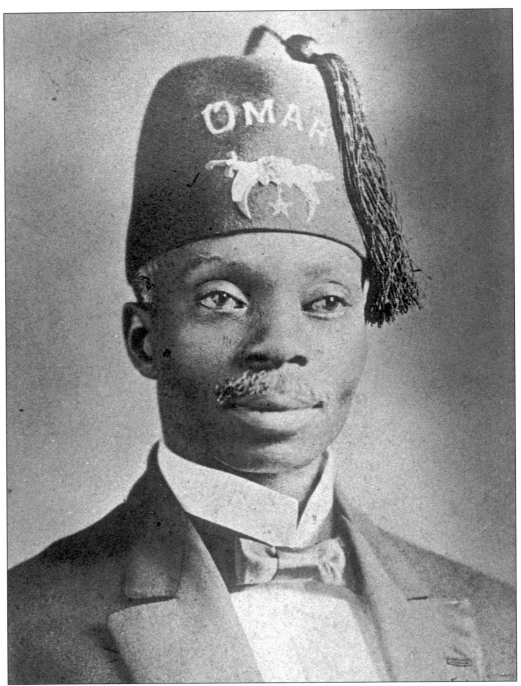

Rev. I.W. Bess of Bess's Chapel AME Church (now Payne Memorial) is pictured here. He was the founder of St. John's Lodge No. 35, Prince Hall Masonic Order. (Courtesy of Library Archives, Grout Museum of History and Science.)

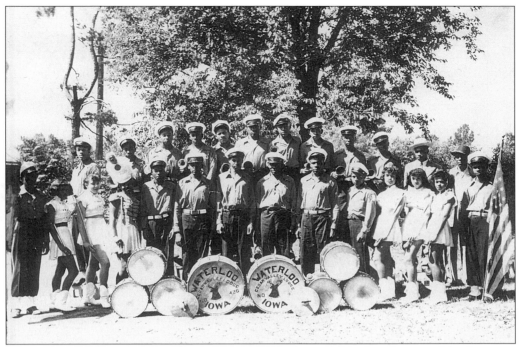

During its active years, the Elks Cedar Valley Lodge #426 had a drum and bugle corps. (Courtesy of Roosevelt Taylor.)

Although the Elks are not in existence in Waterloo, Roosevelt Taylor, a fraternal member, has stayed active through the Des Moines chapter. Taylor, a veteran and retiree of John Deere Component Works, recently received the 1998 CUES Director of the Year national award, the most prestigious recognition for Credit Union Volunteers. (Courtesy of Roosevelt Taylor.)

101

Justus H. Rathbone founded the Knights of Pythias on February 19, 1864. The first African-American Pythian Lodge was organized in Mississippi in 1880. Women were admitted in 1888. Pictured is Mack A. Butler, who, in 1953, established Knights of Pythias Furgerson Lodge #5 in Waterloo. He was also Black Hawk County's first Black deputy sheriff. (Courtesy of Sam Ella McDonald.)

Pictured here is Bursie Williams (1932–1998), as Most Worshipful Grand Master of Prince Hall Grand Lodge of Iowa. (Courtesy of Sheryl Williams.)

Composer Jimmy E. Holiday (whose real name was James Brown) was known for *All I Every Need is You* and *Put a Little Love in Your Heart*. He also collaborated in writing songs with Ray Charles and Eddie Reeves. Holiday is buried in a Waterloo cemetery. (Courtesy of Percy Brown.)

Longtime Waterloo resident Randolph (Randy) Dean, songwriter of gospel and country music, is known for co-authoring the *Hold On* album. (Courtesy of Randy Dean.)

In the early 1940s, this musical group had its 15 minutes of fame on KXEL Radio. Pictured from left to right are Phyllis Henderson, Sanomia, and Marian Butler. (Courtesy of Phyllis Henderson.)

Members have come and gone, but the name "Louis Mctizic and the Blues Reviewers" has been around for a long time. Pictured here is Louis, playing a blues tune on a harmonica. (Courtesy of Louis Mctizic.)

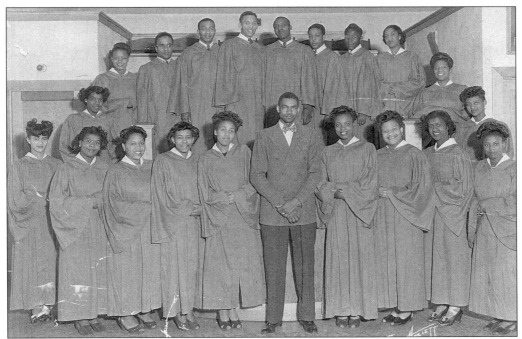

Opened in 1967 in the former St. Peter Claver Catholic Church, Jesse Cosby Neighborhood Center was named for African-American Jesse Cosby, who was nationally known as a square-dance caller. The center currently serves as a meeting place for educational and recreational activities. Pictured is Jesse Cosby (front row, center) with his a-cappella choir. (Courtesy of Phyllis Henderson.)

Under the leadership of Venella Byrd, the senior citizens facility became part of the Jesse Cosby Center in 1978. Pictured here is Venella, with husband Palmer, at a fraternal organization event in 1948. (Courtesy of Venella Byrd.)

Swingers Golf Club of Waterloo started in the late 1960s. The club conducts a golf clinic for Black youth, as well as making various donations to community events to ensure increased interest in the sport amongst minorities. The club also supports a tree nursery at Gates Park. Its major event is the Swingers Tournament, which is held annually in August at Gates Park. Pictured here are current members of the club. (Courtesy of *Waterloo United Communicator*. Photo by Charline Barnes.)

Claude Patterson worked in the foundry of the John Deere Waterloo Tractor Works before becoming a professional wrestler in 1964. (Courtesy of Harold Patterson.)

Don Perkins, former running back for the Dallas Cowboys (1960–1967), grew up in Waterloo. In 1962, he was honored as an All-NFL player. His nephew, Bill Perkins Jr., another native Waterloo athlete, also played professional football. (Courtesy of William C. Perkins Sr.)

Brothers Mike and Reggie Roby were both involved in professional sports. From 1967–1969, Mike played baseball for the San Francisco Giants. He now works for John Deere Company. (Courtesy of Mike Roby.)

Reggie, currently with the San Francisco 49ers, is considered one of the best punters in NFL history. He has played for the Miami Dolphins (1983–1992), Washington Redskins (1993–1994), and Tampa Bay Buccaneers (1995). (Courtesy of Mike Roby.)

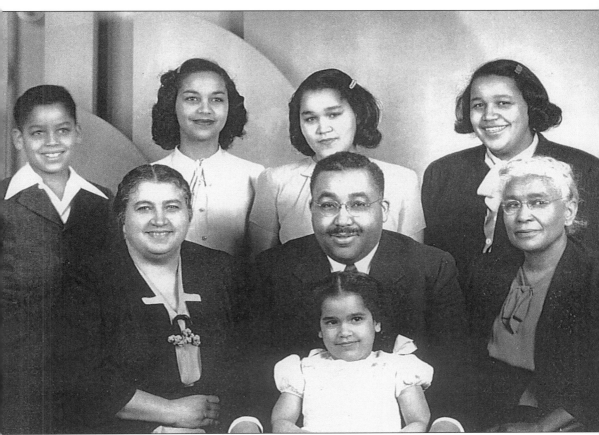

In 1952, Lily Furgerson became the first Black teacher to be hired by the Waterloo Community Schools. She taught for 19 years at Grant Elementary and was a member of the teaching staff when Grant became a Bridgeway school. The Bridgeway Project, a Waterloo Community Schools desegregation plan in the late 1960s, was designed to decrease the number of minorities in certain schools on the east side of Waterloo. In the end, it took open enrollment, along with busing and civil rights laws, to further integrate the public schools in other sections of Waterloo beyond the East Side Triangle that African Americans were restricted to live in. Today a child development center is named in honor of Lily Furgerson. Lily was married to Dr. Lee B. Furgerson, longtime physician in Waterloo. Pictured here is the Furgerson family. From left to right are: (front row) Lily, Lee Sr., who is holding Rebecca (known as Becky), and maternal grandmother Birdie Williams; (back row) Lee Jr., Martha, Lileah, and Betty Jean (known as B.J.). (Courtesy of Becky Furgerson Sloan.)

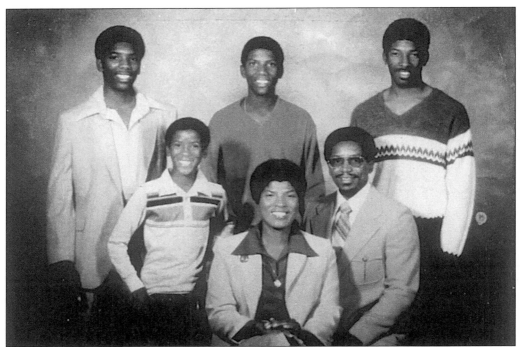

Dr. Walter Cunningham became Waterloo's first African-American school principal, beginning as a math teacher and concluding his career as associate superintendent for Waterloo Community Schools. In 1990, a scholarship was established in his name under the auspices of the Waterloo Fund for Excellence in Education, a non-profit corporation that provides a source of private money for public schools. Pictured here is the Cunningham family. From left to right are: (front row) Benjamin, Ruth, and Walter Sr.; (back row) Walter Jr., Everett, and Jeffrey. (Courtesy of Walter and Ruth Cunningham.)

Dr. Helen Walton began her career in education as a teacher's aide. While raising a family, she returned to school and later became Waterloo's first African-American female administrator in 1979. In 1995, she earned her doctoral degree from the University of Iowa and is currently a human resources supervisor in Indianapolis Public Schools. (Courtesy of Helen Walton.)

Floyd Sr. and Floyd Jr. are believed to be the first father and son to graduate together from the University of Northern Iowa. (Courtesy of Floyd Bumpers.)

The Wright sisters—Barbara Adams, Jacqueline Ellis, and Josephine Boykin—overcame racial and gender inequality to become the city's first Black nurses. Today in Waterloo, many nurses of color are employed by the two local hospitals—Allen Memorial and Covenant—as well as medical offices and institutions. (Courtesy of *Waterloo-Cedar Falls Courier*. Photo by Dan Nierling.)

In the late 1920s, Milton Fields was the first Black attorney to practice in Waterloo. After the death of Fields in 1950, William Parker, a native of Des Moines, took over Fields's law practice in 1951. In January 1963, Parker was elected Waterloo Municipal Court judge—the first Black judge in Black Hawk County. He moved to Washington, D.C. in 1971 to work for the Veteran Administration, until his death in 1973. Pictured here is Waterloo native Judge George Stigler. Currently the only African-American judge in Black Hawk County, he was appointed to the bench of the district court in 1978. (Courtesy of *Waterloo United Communicator*. Photo by Charline Barnes.)

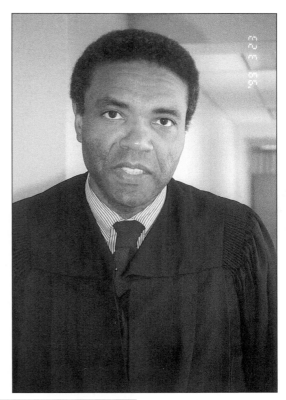

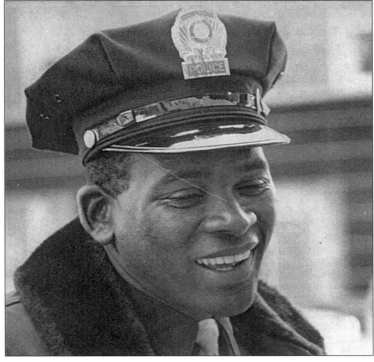

James Cook currently holds the record as being Waterloo's first and only Black detective sergeant. A 1955 graduate of Waterloo's East High School, he began as a foot patrolman in 1967, and in 1972 was promoted to sergeant. He retired from the police force in 1990. (Courtesy of Jim Cook. Photo by David Myers.)

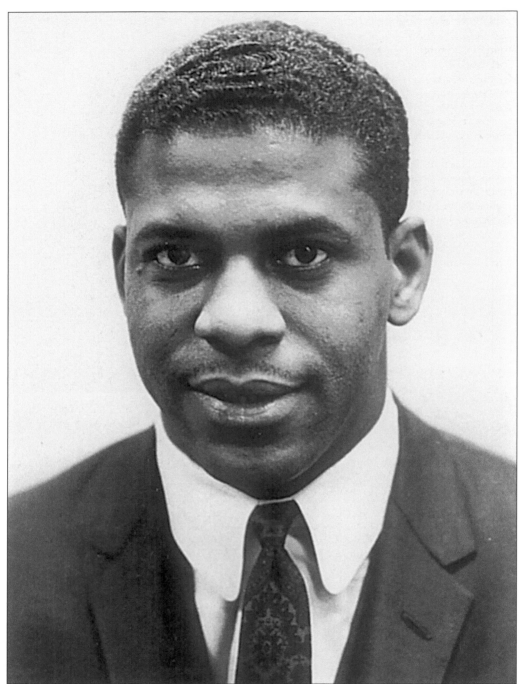

African-American leaders made several unsuccessful attempts for political office in Waterloo prior to 1965, when James H. Jackson, a graduate of Waterloo East High School (1956) and the University of Northern Iowa (1961), became the first African American from Waterloo to be elected to the Iowa Legislature. (Courtesy of Special Collections, University of Northern Iowa.)

In 1973, Mary Berdell won a seat as Fourth Ward representative on the Waterloo City Council after tying with another candidate and winning a drawing. Berdell was the first African American, and the first blind person, to win a seat on the city council. (Courtesy of Phyllis Henderson.)

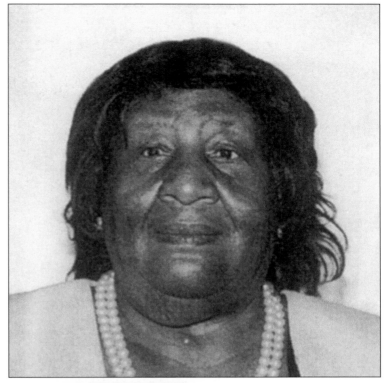

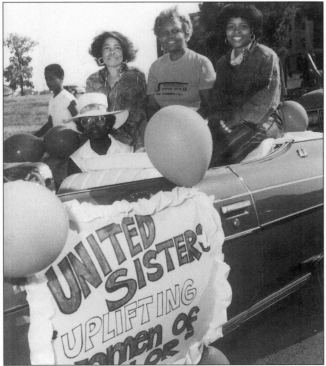

Ruth Anderson, in 1988, became the first African American to be elected to the Black Hawk County Board of Supervisors. She was a professor of social work at the University of Northern Iowa. She is also the author of *From Mother's Aid Child to University Professor: The Autobiography of an American Black Woman*, published in 1985. Pictured is Ruth (centered) with Mary Dickens (wearing hat), Christine Harris (on left), and Christine's daughter Jackie (on right), riding in a car sponsored by the United Sisters of Black Hawk County (also known as United Sisters), an Iowa women's networking organization for women of color that was established in 1987. (Courtesy of Iowa Women's Archives, University of Iowa Libraries.)

Pictured here is John Tyson (1922–1996), one of the first Black, licensed, real estate agents in Black Hawk County, who paved the way for others of color to follow. A graduate of Waterloo East High School in 1941, Tyson was a World War II veteran who worked 35 years for Rath Packing Company while running a successful real estate business. In 1948, he became the first Black realtor and broker in the state of Iowa. He also served on the Iowa Board of Real Estate Commission. (Courtesy of Robert Tyson.)

Denman Phillips Sr. started Denman Phillips Construction Co, Inc. in 1948. Denman Phillips Construction did mostly commercial business, but in the 1950s and 1960s, it was actively involved in the residential building market. After their father's death in 1989, sons Denman Jr. (pictured, died in 1999) and Terry started their own construction business called Kenneth & Warren Construction, now Denter Corporation. (Courtesy of Terry Phillips.)

Formerly known as Stokes Landscaping Inc., the name was changed to Pauline Company in 1985. W.C. Stokes owns Pauline Company Inc., a heavy highway construction firm. Today, Stokes's latest business venture is a housing development project for people 55 years or older. Members of the Stokes family are pictured attending the ribbon cutting ceremony for its Fourth-Street site. From left to right are as follows: Ester, W.C., Wallace Sr., Pauline, and Wallace Jr. (Courtesy of Pauline Company Inc.)

117

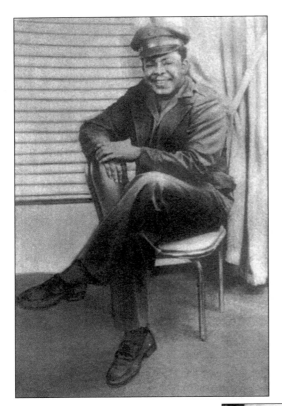

Joe Traywick (pictured in his military uniform) began Joe the Plumber & Son in 1943. A native Mississippian, Traywick became the first Black master plumber in Waterloo. He received his training in Kansas City, Missouri. (Courtesy of Joe Traywick.)

Arthur L. Carter (1916–1997) was an electric contractor and owner of Art Carter & Son Electric since 1954. His son, Derrick, continues to carry on the family business. Art Carter was also instrumental in starting the Minority Contractors Association in Iowa. (Courtesy of Dorothy Carter.)

Margaret Patten-Johnson and Montrose Johnson are seen here in their home. Montrose was Waterloo's first Black mortician. He relocated from Des Moines in the late 1950s. He had his funeral home at 708 Mobile Street, and later moved it to 303 Independence Avenue. (Courtesy of E. Hobart De Patten.)

Pictured here is the father (Nathaniel Mays) and son (Nate Jr.) team of a Black-owned car detailing/appearance business in Waterloo. Nathaniel Sr. was a businessman in Waterloo since the 1920s. He died in 1994. (Courtesy of Nathaniel Mays Jr.)

KBBG Radio (88.1 FM) began its full day of broadcasting in August 1978, operating on 10 watts of power. With Jimmie (CEO) and Lou (President) Porter at the helm of this organization called Afro-American Community Broadcasting, Inc., it is one of several Black-owned and operated community-based education radio stations in the nation. With the motto "Communicate to Educate," this Waterloo-based radio station also provides skills and work experience for minorities in telecommunications, which can lead to jobs in the broadcast industry. Pictured here is the new building on Newell Street. (Courtesy of *Waterloo United Communicator*. Photo by Charline Barnes.)

These are three African-American weekly newspapers published in Waterloo, from 1950 to 1975. B.P. Steptoe was publisher/editor of *Waterloo Post* in the early 1950s. Rev. George T. Stinson served as editor of the *Waterloo Star* in the late 1950s. Harry Ceaser ran the *Waterloo Defender* in the 1970s. (Courtesy of *Waterloo United Communicator*. Photo by Charline Barnes.)

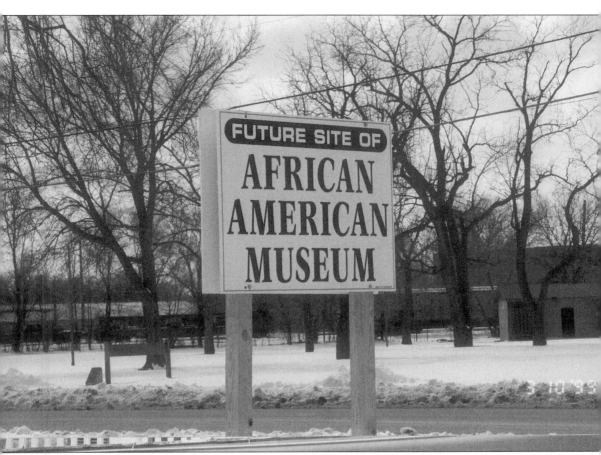

Although the oral history of Waterloo's African-American community is strongly alive, most of it is still unwritten. It is through the continuous efforts of Ruth Anderson, Ada Tredwell, and others who are working on building Waterloo's African-American Historical and Cultural Museum (AAH&C) that this history lives on. The mission of the museum is to cultivate and preserve African-American history and culture in Black Hawk County. Pictured here is a sign of the future museum's site. (Courtesy of *Waterloo United Communicator*. Photo by Charline Barnes.)

The authors are seen here at Lewelling Quaker House in Salem. It is one of the best-known Underground Railroad stations in Iowa. (Courtesy of *Waterloo United Communicator*.)

This is a picture of the trap door inside the Lewelling House that led to a secret hiding place for escaping slaves. (Courtesy of *Waterloo United Communicator*. Photo by Charline Barnes.)

Eleven

GONE, BUT NOT FORGOTTEN

The Underground Railroad was not an actual railroad system—neither was it underground. It was the name for the paths that slaves traveled as they escaped bondage. Supposedly, the term originated when an enslaved runaway, Trice Davids, fled Kentucky without a trace, leaving a bewildered owner, who wondered if the slave had "gone off on some underground road."

The Underground Railroad was not formally organized, and it consisted of both Black and White sympathizers who were concerned about the freedom of the whole human race. Many of the Black people who got involved in the Underground Railroad system had been slaves themselves, and they dedicated their lives to helping others gain their freedom. They understood the long workday, the sizzling heat, the rapes and murders, and the rawhide whip that most slaves faced each and every day of their lives. Escaping slaves followed the North Star. Oftentimes they had to go through swamps and other undesirable places that were home to deadly snakes and alligators. They also faced the possibility of starvation. In addition to those atrocities, the professional slave catchers, who chased them day and night, had bloodhounds that were especially trained and bred to hunt runaway slaves.

Fugitive slaves who were fortunate enough to get across the border into Iowa were directed to a specific private home, church, or schoolhouse that was known as a station. At the station, they were hidden underground in cellars, tunnels, closets, secret rooms, and sometimes up in attics. In addition to shelter, they were given food, clothing, and special care for such ailments as broken bones, dog bites, and sometimes bullet wounds.

Since everything was done in secrecy, it is literally impossible to know how many slaves escaped through Iowa, and it is also impossible to know the many exact routes they traveled. However, one thing is clear—the Underground Railroad came through Iowa and its efforts played a dominant role in abolishing slavery. Let us never forget the Underground Railroad. It symbolizes one of the greatest acts of creative, redemptive goodwill that ever took place on American soil.

The Legendary Story of Buxton

Buxton was a coal mining community, and most of it was in Bluff Creek Township (Monroe County), overlapping into Jefferson Township (Mahaska County). It was never incorporated as a town; however, most people refer to it as Buxton, Iowa. The community consisted of such institutions as schools, churches, a YMCA, a bank, grocery, clothing and hardware stores, train station, and baseball teams. Also, sources said that there were Black professional people such as dentists, doctors, pharmacists, teachers, and lawyers living in the community of Buxton.

When 25-year-old Ben Buxton became superintendent of the mine, he named the camp Buxton. The Buxton mining camp was owned and operated by the Consolidation Coal Company, which was a subsidiary of the Chicago and Northwestern Railroad. There is considerable disagreement about the population of the Buxton community. The figures range from 5,000 to 12,000. However, most writers say the community consisted of 75% Black people, and there are many stories about the racial harmony that existed there.

Many of the Black people came to Buxton from southern states, and migration was a way of searching for a solution to the race problems they encountered as well as earning a decent wage for their labor. Most Buxtonites spoke about the social functions, the school system, and the church activities with affection and admiration. There seems to have been no disparity in pay between Black and White.

The Buxton mine closed in the mid–1920s. The people had to relocate to other places, and today Buxton is only a legendary memory in Iowa's history. The only things left are some bricks from two of the business buildings and an unkempt cemetery located in a thick wooded area.

Marjorie Brown, a longtime Waterloo resident, was born in Buxton in 1904. Here she is pictured at Venella Byrd's retirement party in 1982. (Courtesy of Venella Byrd.)

This is what is left of the warehouse building in the Buxton coal mining town. (Courtesy of *Waterloo United Communicator*. Photo by Charline Barnes.)

Fort Des Moines

Black people have shed their blood in every American military confrontation from the Boston Massacre in 1770 to the present time. However, American historians have done a very poor job of acknowledging and publicizing the African-American war heroes' accomplishments.

The first training for Black officers took place at Fort Des Moines during World War I. Statistics show that over 1,200 African-American men attended officers training school at Fort Des Moines during the World War I era, and many of them led troops and shed their blood on the European battlefield. During World War II, African-American women were also trained at Fort Des Moines.

Let us never forget Fort Des Moines. It symbolizes African-American patriotism and leadership. It symbolizes African-Americans' ongoing fight for freedom—at home and abroad.

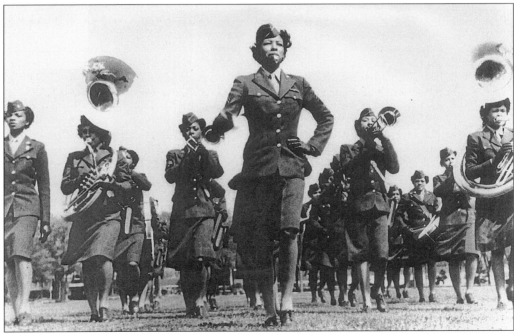

Pictured are some of the first Black Women's Army Auxiliary Corps (WAAC) officers at Fort Des Moines in 1942. (Courtesy of U.S. Army, National Archives.)

ACKNOWLEDGMENTS

"If we forget what in the heck we did a long time ago, we won't know who we are today".
—Ronald Regan

Many community members, public and university libraries, newspapers, and museums contributed valuable information and/or priceless pictures for this publication. Our warmest thanks to them in support of this book.

We give thanks to Dr. Philip Hubbard for taking the time to write the Foreword. He truly affirms the mission of this book.

We are grateful to Rev. Wilson O. Rideout (Payne Memorial AME Church, Waterloo) for giving us a copy of the African Methodist Episcopal Church directory for the Fourth District. It helped to guide our path as we traveled around the state.

We are appreciative to special people such as Roy Backus (First Congregational Church, Burlington), Dick Davin (Dick Davin Realty, Iowa City), Doug Dillavou (Iowa Department of Corrections, Des Moines), Lorenzo H. Duke (Moline, Illinois), Jim Keegel (Eddyville), the late Patricia Warren Roberts (Waterloo), Glenwood Tolson (Mt. Pleasant), C. Jean Schroeder (U.S. Army, Des Moines), Dan Smith (Iowa Department of Corrections, Des Moines), Lyn Stinson (NAACP, Burlington), Janice Edmunds-Wells (Des Moines), and Dennis Williams (Fort Dodge) for taking time out of their busy schedules to share memories, visit sites, and/or give names of contact persons.

Much gratitude to our families and close friends for their understanding, cooperation, and words of encouragement as we traveled throughout Iowa.

As always, we give honor to God for our talents and for providing us the courage to see this project become a reality.

Selected Bibliography

BOOKS:

Bergmann, Leola. *The Negro in Iowa*. Iowa City: State Historical Society of Iowa,1969.

Dykstra, Robert R. *Bright Radical Star: Black Freedom and White Supremacy on the Hawkeye Frontier*. Ames, Iowa: Iowa State University Press, 1993.

Halpern, Rick. *Meatpackers: An Oral History of Black Packinghouse Workers and Their Struggle for Racial and Economic Equality*. New York: Twayne Publishers, 1996.

Haskins, Jim. *Get on Board: The Story of the Underground Railroad*. New York: Scholastic Publishers, 1993.

Morris, Robert V. *Tradition and Valor: A Family Journal* (forthcoming). Kansas: Sunflower University Press, 1999.

Schwieder, Dorothy. *Iowa: The Middle Land*. Ames, Iowa: Iowa State University Press, 1996.

Schwieder, Dorothy. *Black Diamonds: Life and Work in Iowa's Coal Mining Communities, 1895–1925*. Ames, Iowa: Iowa State University Press, 1983.

JOURNALS:

"African-American Iowans: 1830s–1970s." *The Goldfinch* 16.4 (Summer 1995).

Hill, James L. "Migration of Blacks to Iowa, 1820–1960." *Journal of Negro History* 66 (1981–82): 289–303.

Neymeyer, Robert. "May Harmony Prevail: The Early History of Black Waterloo." *The Palimpsest* (1980): 80–91.

Pelzer, Louis. "The Negro and Slavery in Early Iowa." *Iowa Journal of History and Politics* 2 (1904): 471–484.

WEBSITE:

Iowa Division of Tourism (1998). www.state.ia.us

About the Authors

Charline J. Barnes is currently an assistant professor of reading education at the University of Northern Iowa. She teaches courses in reading diagnosis and remediation and language arts across the curriculum. Before joining the faculty at UNI in 1996, she taught and supervised student teachers at South Dakota State University. Dr. Barnes was a public school teacher for ten years, with nine of these for Fairfax County (Virginia) Public Schools. She is also the associate editor of *Waterloo United Communicator*. Her hobbies include traveling and reading. She has published in academic journals on literacy and multicultural issues in education.

While employed full-time, Floyd Bumpers Sr. completed his bachelor's degree at the University of Northern Iowa. Floyd, a 35-year resident of Iowa, is a retired machinist from John Deere Waterloo Tractor Works. To pursue his lifelong endeavor to become a writer, in 1997 he launched the *Waterloo United Communicator*, an African-American, community-based newspaper in Northeast Iowa. Floyd enjoys reading materials about/by African Americans. He has two adult sons and two grandchildren.